IMAGES
of America

THE POLISH COMMUNITY
OF WORCESTER

IMAGES
of America

THE POLISH COMMUNITY
OF WORCESTER

Barbara Proko, John Kraska Jr.,
and Janice Baniukiewicz Stickles

ARCADIA
PUBLISHING

Published by Arcadia Publishing
Charleston SC, Chicago IL, Portsmouth NH, San Francisco CA

Printed in the United States of America

Library of Congress Catalog Card Number: 2003110238

For all general information contact Arcadia Publishing at:
Telephone 843-853-2070
Fax 843-853-0044
E-mail sales@arcadiapublishing.com
For customer service and orders:
Toll-Free 1-888-313-2665

Visit us on the Internet at www.arcadiapublishing.com

To my parents, Alphonse and Josephine Proko, and my grandparents, Alexander and Stefania Ruscik Prokopowicz and Julius and Anna Blaszko Prokopowicz—people of integrity, courage, strength, intelligence, humor, and compassion, whose remarkable lives sparked my passionate interest in Polish genealogy, history, and culture.
—*Barbara Proko*

To my parents, John and Regina Kraska, and my grandparents, Martin and Tekla Kraska and Stanley and Agatha Golas, for always insisting that the family be aware of its rich heritage by speaking the language, attending cultural events, and preserving Polish traditions.
—*John Kraska Jr.*

Dziekuje bardzo to my parents, Joseph and Jennie Brodzik Baniukiewicz, for their love and support; my grandparents Jan and Maria Soliwoda Brodzik for tales of the old-country family life; Mieczyslaw and Stanislawa Wlodkowska Baniukiewicz for their sense of humor; and my husband, Dean, for sharing in our Polish traditions.
—*Janice Baniukiewicz Stickles*

CONTENTS

ACKNOWLEDGMENTS

For invaluable assistance and information, we thank Rev. Thaddeus Stachura, the Sisters of the Holy Family of Nazareth, and Jane Horuzek, all of Our Lady of Czestochowa Parish; and Deacon Joseph Baniukiewicz, Henry Kolakowski, Lorraine Laurie, Rosalie Tirella, the Central Massachusetts Convention & Visitors Bureau, the Polish Heritage Center of Central Connecticut State University, the Worcester Historical Museum, the Worcester Public Library, and the Worcester Regional Chamber of Commerce.

We are very grateful to Rosemary Gradie for permission to use photographs made by Peter Nappellio Sr., who focused his camera lens on our Polish community for more than a decade; to Alice Richmond, for use of photographs by the Marvin Richmond Studio; and to the *Worcester Telegram & Gazette* for use of news photographs and Al Banx cartoons. All these professionals captured precious moments in time with insight, style, and skill.

For generously sharing their treasured photographs and memorabilia, we are deeply indebted to Robert Baniukiewicz Sr., Mary Benedict, Herbert Berg, Robert Buyniski, Barbara Antas Courtney, Helen Eddey, Helen Hryniewicz, Sally Jablonski-Ruksnaitis, Thaddeus Jankowski, Irene Johnson, Al Józefowski, Lyn Kaminski, Henry Karolkiewicz, Jane Kerins, Regina Kraska, Dorothy Kuczka, Helen Kulak, Robert Largess, Rev. Richard Lewandowski, Chester Makowiecki, Rose Massey, Deborah Proko McIntosh, Mary Parsons, Zigmond Prostak, Janet Prokopowich, Sophie Pruszynski, Rosemary Quagan, Joan Radula, Stephen Rojcewicz Sr., Rita Sinasky, Paula Skowronski, Patricia Recko Smith, Stasia Stodulski, Dorothy Strzelecki, Edward Swillo, John Szlyk, Tadeusz Tarasiak, Mary Toboika, Sophie Gawronska Vasil, Regina Wolanin, Stanley Wondolowski, Walter Wondolowski, Raymond Zaleski, Peter Zinkus, the Polish American Veterans, and Polish Naturalization Independent Club.

Several members of St. Mary's High School's Class of 1964—Irene Nowak Chiarvalloti, Christine Hryniewicz Chila, Ann Marie Gebski Creed, Thomas Kasprzak, Robert Szklarz, Eugene Zabinski, and Ilene Zaleski—also contributed key materials and assistance. We feel a special bond with them. We cherish, beyond measure, the unique relationships we developed in our 12 years together at St. Mary's.

We owe much to the Sisters of the Holy Family of Nazareth. As our teachers, they instilled in us the values that have nurtured the Polish spirit for hundreds of years.

INTRODUCTION

This book explores the history of the Polish community in Worcester in its first century, from 1870 to 1970. It highlights the period of most active growth, between 1900 and 1965. Settlement was sparse in the first 30 years, with only some 150 families. By 1930, however, the number of Poles had swelled to 10,000, the result of the great wave of immigration that preceded World War I and forever changed the face of Worcester from native Yankee to foreign born. Their numbers made the Polish immigrants one of the city's largest ethnic groups.

The Poles settled in the working-class east side of Worcester. They lived in the three-decker neighborhood known as the Island, an area that began north of Kelley Square and was bounded roughly by Vernon Street on the east and Quinsigamond Avenue on the west. The sprawling American Steel & Wire Company mill, at the intersection of Millbury, Vernon, and Ballard Streets, marked the south end.

On the Island, the Poles bumped shoulders with the long-established Irish and with the Lithuanians and Jews, with whom they had shared steerage in passage to America. This Polish-Lithuanian-Jewish mix was a natural carryover for newcomers from the Russian Poland provinces of Wilno, Suwalki, Grodno, and Lomza. In some respects, the Russian Poles shared more common experiences with the Lithuanians and Jews than they did with the smaller group of immigrant Poles from Austrian-controlled Galicia.

The Russian and Austrian Partition Poles did have one thing in common: most had come to this teeming industrial city, the second largest in New England, from small farming villages of a few dozen or hundred people. Lacking English skills or much formal education, they accepted factory jobs for bottom-tier wages. In the mills that surrounded the Island, they helped create top-quality goods known nationwide: wire that staved off German U-boats in the North Sea, looms for the textile industry, oriental-style woolen rugs, Pullman cars, and electric trolleys.

The Poles' desire to practice their Catholicism in their native language produced St. Mary's Parish, later known as Our Lady of Czestochowa. Between 1905 and 1919, their meager wages funded the construction of a beautiful 750-seat church, a rectory, a convent, and an elementary school that was expanded twice to accommodate 1,500 students by 1928. The crowning glory was St. Mary's High School, which opened in 1936 to become the only Polish secondary school in New England.

The Polish immigrants adapted to American life but held Poland close to their hearts. Beyond registering for the U.S. draft, as required in World War I, 200 of Worcester's Poles enlisted in "Haller's Army," a Polish army fighting in France with hopes for their homeland's

freedom and reunification. Determined to maintain their ethnic identity, Worcester's Poles founded strong social, cultural, and civic organizations. By the time the Polish Naturalization Independent Club celebrated its 50th anniversary in 1956, it had helped 3,000 members attain U.S. citizenship and supported some who were seeking political office. A thriving business community of retail stores and myriad services developed on Millbury Street, Polonia's "Main Street."

The 1930s and 1940s saw the immigrants' children, Worcester's first Polish Americans, graduate from high school and the immigrants themselves attend night school because education was the route to citizenship and better jobs. The community saw some of its own finally achieve political posts. World War II, sparked by the invasion of Poland, had a deeply personal impact upon Polonia. The 1950s confronted the community with several crises: the dynamic tension between ethnic and cultural integrity and assimilation into the American mainstream; the retirement of Msgr. Boleslaw A. Bojanowski, who had guided the parish for 41 years; two fires in St. Mary's schools; and interstate highway construction that ripped through the heart of the neighborhood.

With the resilience that has characterized the Poles for centuries, the Worcester community used all these challenges as springboards to greater solidarity. Throughout the 1960s, Worcester's Polonia retained its vibrancy, as some of Millbury Street's landmark businesses expanded, St. Mary's High School achieved academic and athletic honors, the ranks of professionals grew, and social and economic status generally improved. With all of these achievements, the community displayed steadfast loyalty to its ethnic and religious roots.

The century saw a number of key figures emerge in Worcester's Polonia. Monsignor Bojanowski was a highly educated concert violinist who spoke six languages and freely expressed his political views from the pulpit; his influence on the people was unparalleled. Joseph Targonski Benedict was a model of outstanding citizenship and achievement. Joseph Buyniski founded Vernon Drug Company, which was the oldest family-run drugstore in Worcester when it celebrated its 70th anniversary in 1982. Charles Sharameta operated Charles Restaurant for more than 60 years, making it the city's oldest family-run restaurant under continuous management. "Ziggy" Strzelecki and Eddie Urbec were highly respected as athletes and gentlemen. All these individuals earned recognition within and far beyond the Polish community. As the ultimate symbols of team spirit, St. Mary's High School's Eagles became local heroes and legends in their own time, with an undefeated season in 1960 and the New England championship in 1964.

As we examine the risks our immigrant grandparents took in leaving behind all that was familiar to them in Poland, the challenges our parents faced as first-generation "hyphenated" Americans, and the achievements we have striven for over three generations, we tell our community's story with images that have come largely from old trunks and family albums never before seen by the public. Dozens of members of our community offered to share their precious photographs and memorabilia in this book, seeking nothing in return. They asked only two questions: "What can we do? How can we help?" That is the best of the Polish spirit, and it remains strong and vibrant in Worcester.

One

FROM POLAND
TO AMERICA

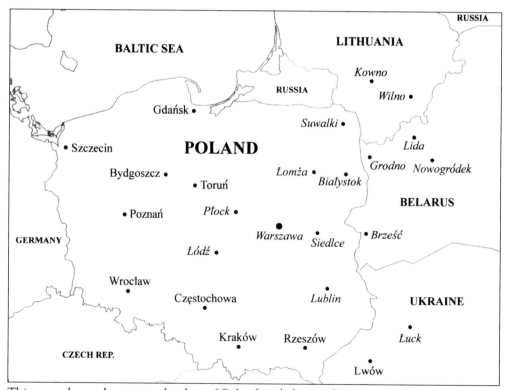

This map shows the current borders of Poland and the neighboring countries of Lithuania, Belarus, and Ukraine, which now encompass areas that were part of Poland between 1918 and 1939. All the cities are identified here by their traditional Polish names. Cities that were within the Russian Empire's Polish provinces until 1918 are set in italics.

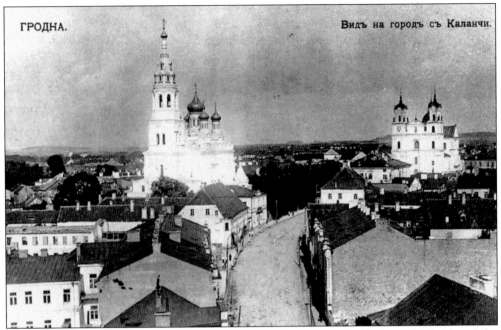

ГРОДНА.

Churches dominate the skyline in this 1914 view of Grodno. Settled on the banks of the Niemen River *c.* 1127, Grodno was one of the largest cities in Russian Poland, with a population of 44,575 in 1887.

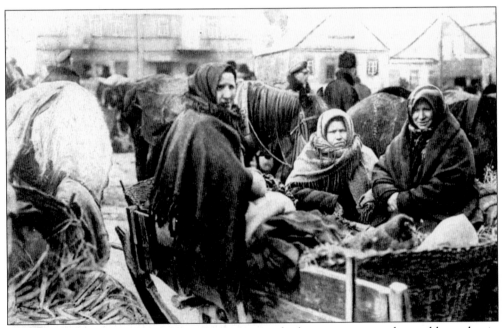

Peasants from nearby villages sold produce, grain, and other necessities at the weekly market in Lida, pictured here *c.* 1920. Traditional occupations in the area were farming, cattle breeding, and linen weaving. Located 60 miles south of Wilno, Lida has served as a sort of county seat for some 400 years.

Conscription for long, hard years in the czarist army was seen as a fate equal to death and a good reason to emigrate from Russian Poland. After his brother Józef was drafted to serve in this group, Kazimierz Szarameta (Charles Sharameta) left his Szczuczyn Litewska home for America in 1913. His brother Antoni followed.

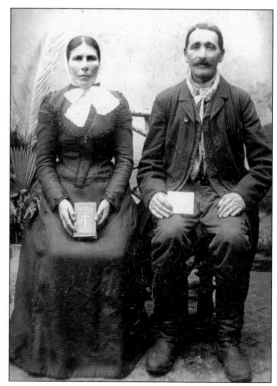

Stasia Sieradzka's grandparents sat for this portrait at the F. Pawlowski studio in Plock, a city northwest of Warsaw along the Vistula River. Immigrants sailing in steerage were limited in what they could carry to America, but their bags typically included photographs of the loved ones they were leaving behind.

The railroad station in Bastuny, built in 1895, was one of the stops along the line that ran north from an important junction in Baranowicze through Lida to Wilno and the port of Libau, Latvia. An extensive rail network facilitated travel from small Polish villages to major European ports.

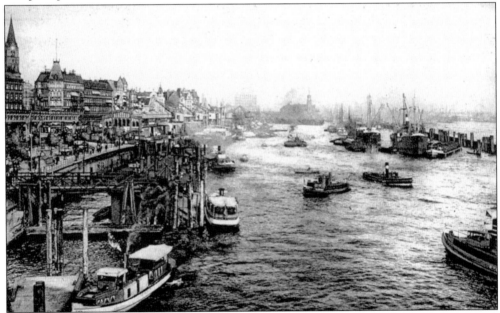

Before World War I interrupted emigration in 1914, millions of Eastern Europeans sailed from the port of Hamburg, Germany, to embark upon a new life. Bremen had been Germany's busiest port in the 19th century, but Hamburg constructed facilities geared to mass emigration and soon eclipsed Bremen as Germany's primary port of departure.

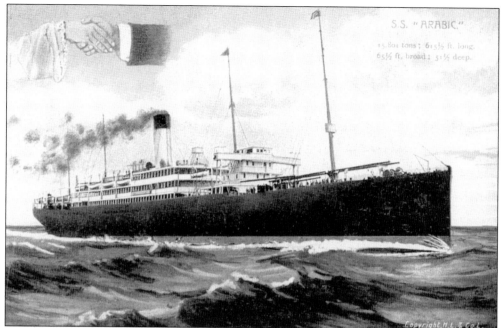

S.S. "ARABIC."

15,801 tons; 615½ ft. long.
65½ ft. broad; 31½ deep.

The White Star Line's *Arabic* was one of the hundreds of passenger ships that carried 23.4 million immigrants to America between 1881 and 1920. The *Arabic* sailed from Liverpool to New York and Boston, carrying 400 first- and second-class and 1,000 third-class or steerage passengers. Poles began their voyage in a port such as Hamburg and then continued from Liverpool.

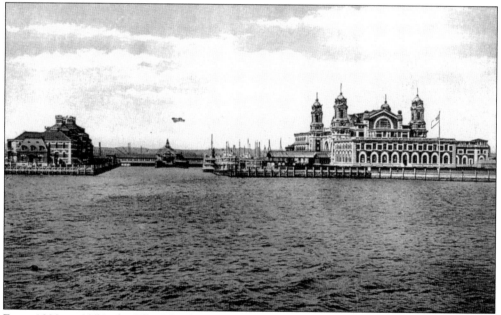

From 1892 to 1954, the Ellis Island Immigration Center processed approximately 12 million newcomers to the United States. From New York, the newcomers would have traveled by train to final destinations such as Worcester. Boston was the second busiest port of arrival, and a convenient one for immigrants settling in Massachusetts.

13

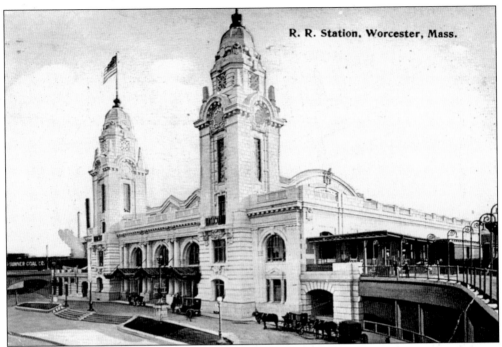

R. R. Station. Worcester, Mass.

Postmarked 1913, this card shows horses and carriages pulled up in front of Union Station. Trains would have been the primary means of transportation to Worcester for immigrants arriving from Europe at the ports of either New York or Boston. Within Massachusetts, trolleys were also important to mass transit.

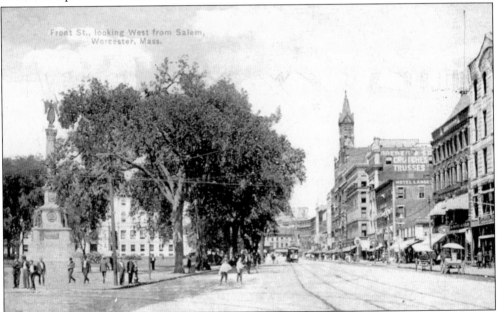

Front St., looking West from Salem, Worcester, Mass.

A postcard of Front Street, looking west from Salem Street, shows part of Worcester's bustling downtown retail area on the right, the Soldier's Monument at left, and city hall in the background, partially hidden by the large trees. Immigrants from rural Russian Poland would have experienced few cities the size of Worcester.

14

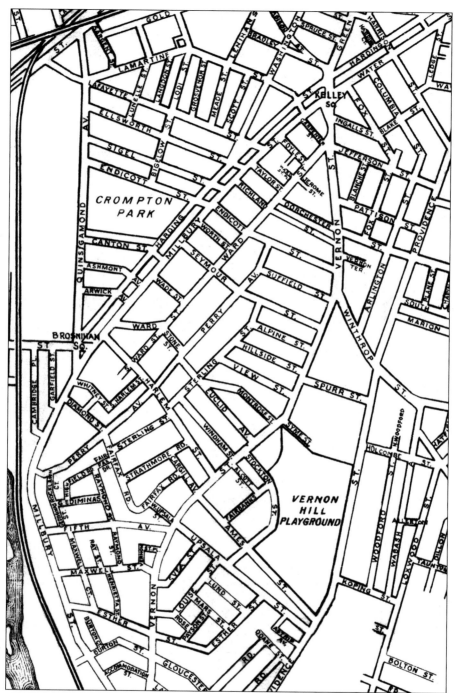

This 1945 vintage map shows the area that was home to Worcester's Polish community. The north end centered on Kelley Square, with some key social halls on Green Street. The American Steel & Wire Company South Works mill marked the southern boundary. Railroad tracks and a branch of the Blackstone River lay west of Quinsigamond Avenue. Vernon Street was the main thoroughfare of the residential Vernon Hill area. The Island, as it was known, is on the east side of Worcester.

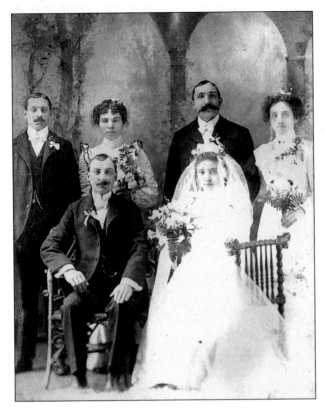

Mateusz Kaminski and Józefa Hylicka (seated) were married in Worcester in 1901. Standing, from left to right, are the groom's brother, Simon, the bride's sister and brother, and an unidentified woman. The Kaminskis resided on Dorchester Street and raised nine children: Charlotte, Jean, Helen, Irene, Riki, Walter, Benjamin, Edmund, and Chester.

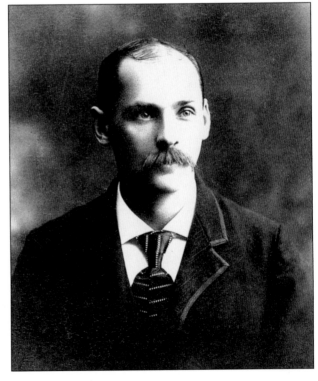

Jan Wodzinski was one of Worcester's earliest Polish settlers, emigrating in 1893 from the Kalisz district of Poznan in Prussian (German) Poland. His wife and three daughters joined him eight years later. The family was among the founders of Our Lady of Czestochowa Parish. Wodzinski is shown here at age 38 in 1901.

16

Aniela "Nellie" Kulikowska arrived in the United States in 1913, coming from the village of Jatowty in the Lida district of Wilno province. She may have worked in the Lowell cotton mills before settling in Worcester, where she continued millwork and boarded with her cousin at 617 Millbury Street.

DYKCYONARZ

KIESZONKOWY

POLSKO-ANGIELSKI

— i —

ANGIELSKO-POLSKI

ZAWIERA:
12,000 SŁÓW POLSKICH
18,000 SŁÓW ANGIELSKICH

Opracował
LEONARD SZUMKOWSKI M. D.

"Osoba umiejąca tysiąc słów dauego języka może załatwiać wszelkie codzienne interesa"
— Gladstone

Wydanie 3ie; poprawione

Copyright, 1912, by L. Szumkowski
Copyright, 1908, by L. Szumkowski
·CHICAGO
MADE IN U. S. A

A pocket-sized Polish-English–English-Polish dictionary was invaluable in helping the immigrant communicate in this new land. Also helpful was a Polish language newspaper published in the Boston area from 1915 to 1972. Worcester news was featured in the "Poles in New England" column in *Kuryer Codzienny*. The popular paper, later known as *Gazeta Polonii*, covered world, national, state, and local news.

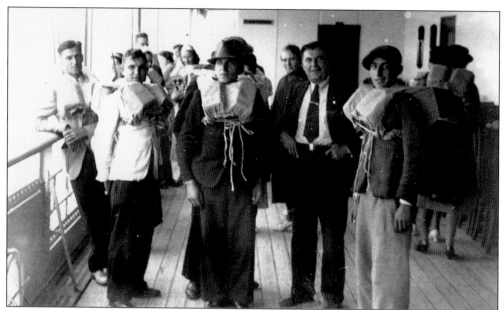

Albert Hryniewicz (right foreground) and a group of fellow passengers wear life jackets as their ship prepares to dock at Ellis Island in 1937. Hryniewicz was born in Massachusetts, but his family returned to Poland during his childhood. Anticipating war in the late 1930s, he and his siblings fled to America. Their parents died in Poland.

The 1920 U.S. Census lists the origins of some of Worcester's Polish immigrants. Lomza, Kowno, Grodno, and Vilna (Wilno), all provinces in Russian Poland, are cited as the birthplaces of the 11 adults reported at 127–133 Millbury Street. Most of them reported arriving in the United States between 1910 and 1913.

Two

HOME AND FAMILY

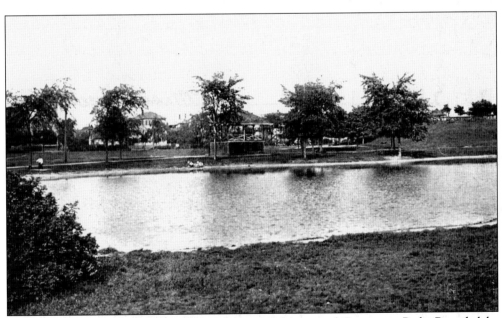

The swimming area beckons in this early postcard image of Crompton Park. Bounded by Endicott, Harding, and Canton Streets and Quinsigamond Avenue, this 15-acre park also offered children's playground equipment such as swings, slides, and sandboxes, along with ball fields and a picnic area. For families whose three-decker homes had limited yards, Crompton was a haven for young and old alike.

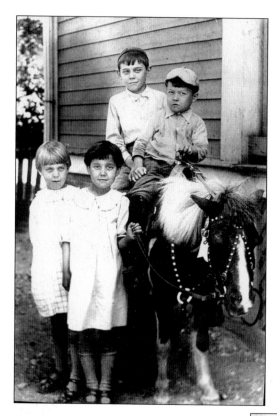

The children of Julius and Anna Prokopowicz pose with a pony outside their home at 585 Millbury Street *c.* 1926. From left to right are Stacia (born in 1919), Vitella (born in 1920), Alphonse (born in 1917), and Julius (born in 1922). The pony belonged to an itinerant photographer who went door to door, offering his services. He charged $1 for two photographs.

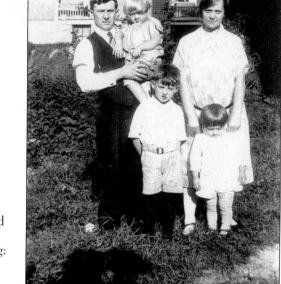

The Golas family gathers in the backyard of 3 Hillside Street in the summer of 1929. From left to right are the following: (front row) sons Michael and Thaddeus; (back row) father Stanley, holding his daughter Regina, and mother Agata.

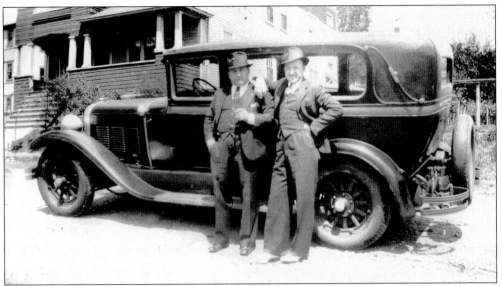

A new automobile gives Michael Karpuk (left) and Alex Listewnik good reason to pose outside the Karpuk home at 111 Ingleside Avenue in the 1930s. Listewnik resided at 14 Langdon Street.

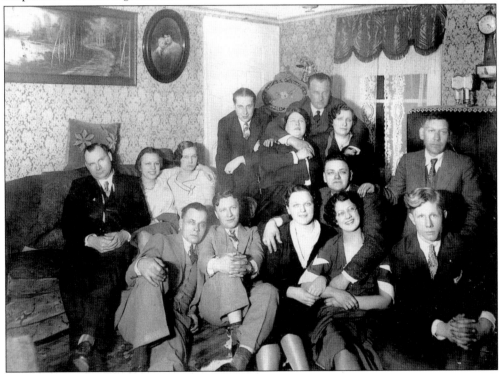

Young adults from Worcester are shown here during a mid-1930s visit to Salem, another community with a sizeable Polish population. The group from Worcester includes John Prokopowicz, seated on the floor at far left, with his future wife, Theodora Mattson Jeffcoat, directly behind. Next to John is his cousin Joseph Michael Prokopowicz. Seated next to Theodora is Joseph's wife, Anna Shilale Prokopowicz. Standing to the left of the window are Thomas and Stella Nadolny, with Charles Boris directly in front.

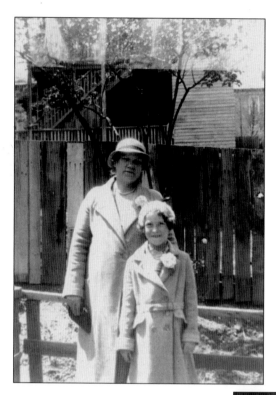

Anna Tobojka and her daughter, Mary, stand on the porch of their home at 111 Harrison Street in a photograph dated June 3, 1934. They appear to be dressed for church or a visit.

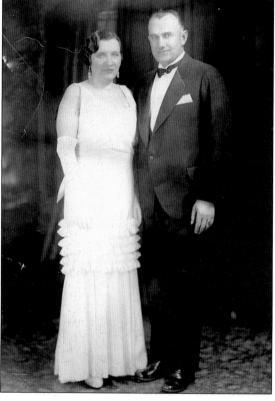

Stefania "Stella" Prokopowicz and Thomas Nadolny, shown here at their 1930 wedding, operated a bakery at 17 Lamartine Street until they retired in 1955. Known over the years as Nadolny's Modern Bakery and the Lamartine Street Bakery, it was advertised as "the oldest Polish bakery in Worcester," offering a variety of breads, cakes, and pastries for all occasions.

In this photograph taken *c.* 1935, Victoria Lemanski (left) and her friend Gladys Sztepaniak model some contemporary fashions. Hats were everyday accessories, and hemlines were low during the Great Depression.

Four of the nine children of Julius and Anna Prokopowicz gather for a Memorial Day photograph on May 29, 1937. The boys are, from left to right, Joseph, Daniel, and Lucien. Older sister Jane holds the group together as they pose near their home at 320 Millbury Street.

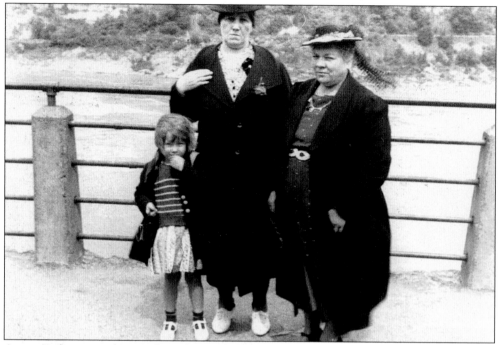

Annie Prokopowicz, her mother, Anna Blaszko Prokopowicz, and Rose Waranowski sightsee at Niagara Falls in July 1940. Julius and Anna Prokopowicz and three of their children drove to Tonawanda, New York, for a visit with Rose and her husband, John. The Waranowskis had moved from Worcester when Wickwire Spencer Steel Company made new jobs available at its plant near Buffalo.

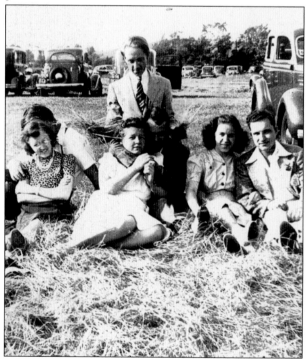

Greenwood Dairy in Millbury was the site of several parish picnics in the 1940s. Enjoying a day in the country are, from left to right, the following: (seated) Adele and Benjamin Siemaszko, two unidentified people, Helen Glowik, and Albert Hryniewicz; (kneeling) Willie Glowik, Helen's brother. Anthony M. Konisky and his sons, Anthony F. and Raymond F., owned and operated the dairy farm.

Brothers Robert and Thomas Radula flank their younger cousin, Joseph Radula Jr., in this 1937 photograph. The occasion was Joseph's sixth birthday. The older boys were the sons of Louis and Frances Radula of Lafayette Street.

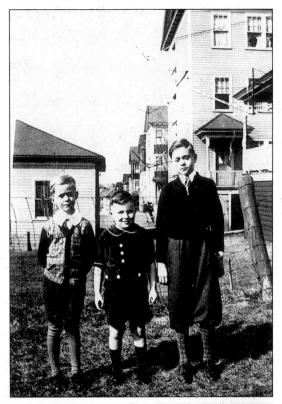

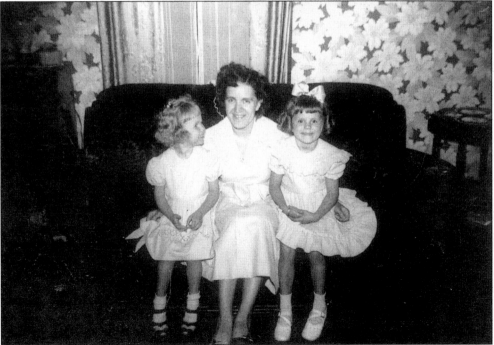

Helen Hryniewicz is seated with her daughters, Jean (left) and Christine, in the living room of their Halmstad Street home in Quinsigamond Village, c. 1953.

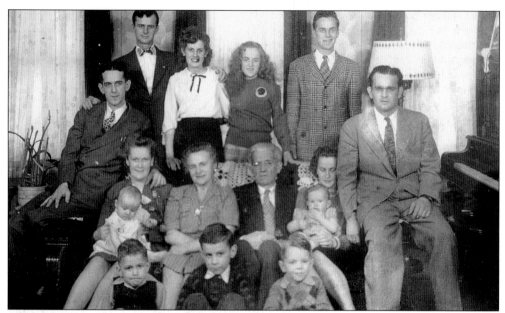

The Baniukiewicz family gathers at the home of Mieczyslaw and Stanislawa Wlodkowska Baniukiewicz at 90 Vernon Street in late 1946. From left to right are the following: (front row) Robert, Joseph, and Stanley; (middle row), Joseph, Jennie Brodzik Baniukiewicz with Janice on her lap, Stanislawa, Mieczyslaw, Cecilia Siminski Baniukiewicz with Diane on her lap, and Stanley; (back row) Eugene, an unidentified friend, Theresa, and Thaddeus Baniukiewicz. Robert, Joseph, and Janice are Joe and Jennie's children; Stanley and Diane are Stanley and Cecilia's.

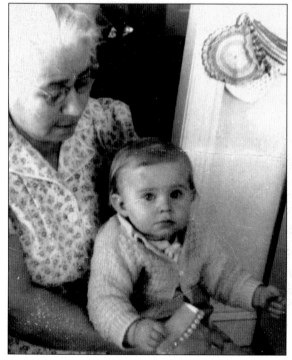

Stefania Ruscik Prokopowicz holds her granddaughter, Barbara Proko, in the family's Harwich Street kitchen in October 1947. Over the years, *Babcia* (the affectionate Polish term for grandmother) told the girl many stories of her early life in Gierniki, a small farming village in the Lida district of Wilno province, in Russian Poland.

Seven-year-old Ilene Zaleski (right) appears fascinated with Denholm & McKay's 1953 department store Santa; four-year-old brother Jack looks dubious. The girl's classic "baloney curls" were made by twisting sections of hair around a finger and anchoring them with bobby pins. Removing the pins allowed the curls to cascade downward.

Chester Kasprzak steadies his son, Tom, as the toddler appears poised to try out the new rocking horse by the Christmas tree c. 1947. The Kasprzaks were celebrating the holidays at their 181 Washington Street home.

Three friends form a tight group in this photograph taken *c.* 1947. Pictured from left to right are Jackie Murphy, Joan Radula, and Robert Zdonczyk. The family of Louis J. and Frances B. Radula resided at 26 Lafayette Street; the couple also had two sons, Thomas and Robert.

Ted Golas leans on the bubbler at Gaskill Field in 1943. For New Englanders, "bubbler" is the familiar term for a water fountain. Stone bubblers like this were common in the city's parks and playgrounds. The three-deckers of Providence Street are in the background.

Regina Golas stands near the intersection of Vernon and Spurr Streets in the spring of 1942. St. Vincent's Hospital fills the background. "St. V.'s" offered healthcare in a Catholic setting on Vernon Hill. Evolving to become Worcester Medical Center, the hospital eventually had facilities at 25 Winthrop Street and Worcester Center Boulevard.

A 1944 outing brings the Polish Falcons to Tattasit Beach on Lake Quinsigamond in Shrewsbury. Pictured in the second row, from left to right, are George Polanik, unidentified, Loretta Górski, Wanda Górski, Mary Polanik, unidentified, and Virginia Stoklosa. The other individuals are not identified.

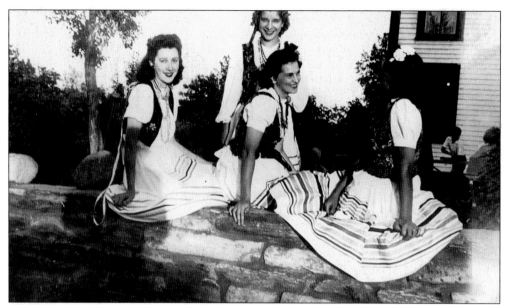

Wearing ribboned skirts and embroidered vests, four young women add a traditional touch to a 25th wedding anniversary party in August 1942. Pictured from left to right are Helen Radula, Regina Bylinski, Helen Baniukiewicz, and Natalie Pawlina. The party at Bonnie Brook in Grafton was held in honor of Joseph and Magdalena Stoklosa.

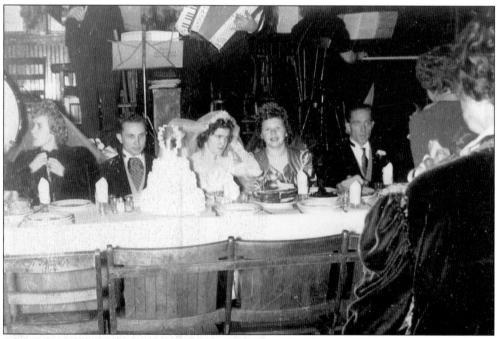

With their wedding cake placed before them, newlyweds Albert and Helen Glowik Hryniewicz share conversation with guests at their reception at the Polish National Alliance hall on Lafayette Street. They were married on Saturday, November 21, 1942, in a 9:00 a.m. ceremony. Weddings were typically held on Saturday mornings in that era.

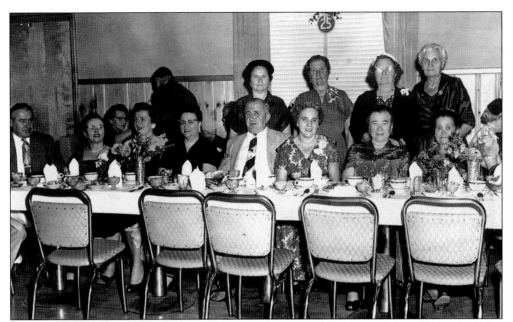

Family and friends enjoy coffee and dessert at a 25th wedding anniversary celebration held at the Polish Naturalization Independent Club *c.* the 1940s. Seated next to each other at the table are sisters Katarzyna Glowik (far right) and Eva Misiuk, with Anna Kiewra (right) standing behind them.

Henry and Josephine Karolkiewicz are dressed for an evening out in 1947, the year of their marriage. The two were active in community organizations, with Henry serving as an officer of the Polish-American Veterans of World War II, the White Eagle Association, and St. Mary's Boosters, and Josephine involved in the Polish-American Veterans Auxiliary, St. Vincent's Hospital Guild of Our Lady of Providence, and various alumni groups.

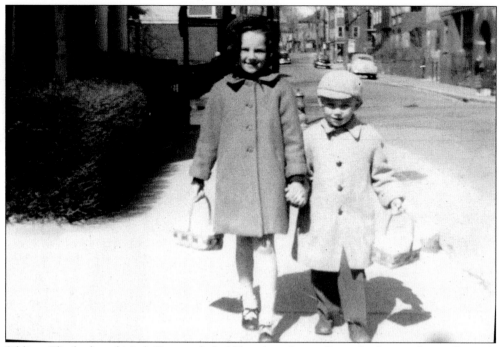

Siblings Elizabeth and Mark Gawronski hold hands and carry Easter baskets as they walk south along Ward Street in the mid-1950s. Visible on the left is the columned entrance to Józefowski Funeral Home at the corner of Endicott Street.

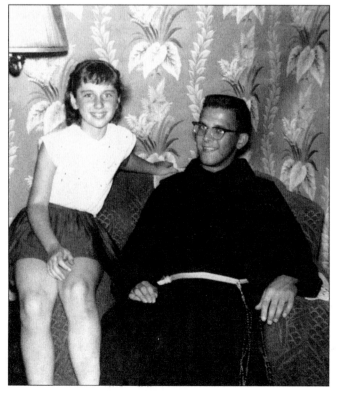

Edward Makowiecki, the youngest son of Andrew and Mary Makowiecki, sits in the front room of the third floor of his parents' tenement at 3 Hillside Street during a 1958 visit. Sitting with him is his cousin, Jane Kraska. Makowiecki had just professed his simple vows with the Brown Franciscan Friars in Pulaski, Wisconsin, taking the name Brother Ladislaus.

John T. Prokopowicz poses with his niece, Deborah Proko, during a March 1959 business trip and family visit. Prokopowicz, who resided in California from 1947 to 1966, was a labor contract negotiator for U.S. steelworkers unions. He returned to Worcester following his wife's death. In an editorial published in the late 1960s, the *Worcester Telegram* described him as one of the city's top labor leaders.

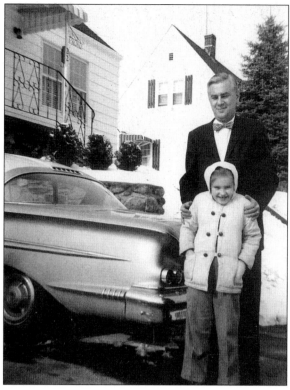

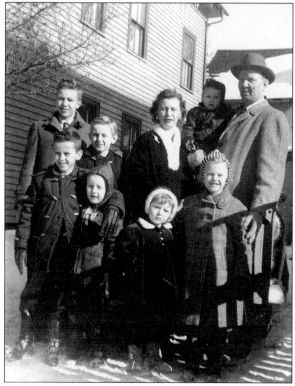

Chester and Anna Lewandowski pose with seven of their nine children in front of their home at 18 Langdon Street in 1957. Pictured from left to right are the following: (front row) Richard, Thomas, Carolyn, and Mary Ann; (back row) young Chester, Stanley, Anna, John, and Chester Lewandowski.

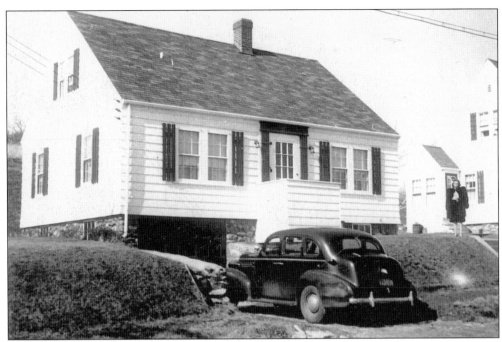

Alphonse and Josephine Proko were the first couple in their families to move from a three-decker to a single-family home. They bought this Cape Cod at 22 Harwich Street in Quinsigamond Village and moved in on their first wedding anniversary in November 1941. Josephine Proko is shown standing on the front walk.

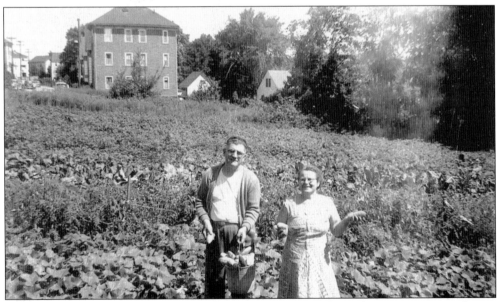

Alexander J. and Michalina B. Zaleski harvest vegetables from their extensive garden at 44 Whipple Street c. 1960. Every year, they planted corn, potatoes, tomatoes, beans, squash, beets, carrots, radishes, and more. Surplus potatoes and carrots were buried in the root cellar for winter use. The garden's success was always attributed to fresh cow manure from a local farm.

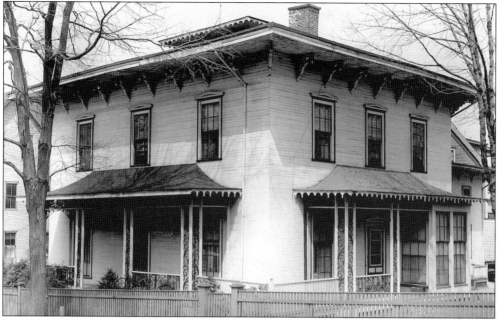

The William B. Fox mansion at 11 Ingalls Street, erected *c*. 1845, was the home of Stanislaw and Viola Zabinski and their extended family from 1945 to 1959. William B. Fox was a wealthy landowner who operated a large woolen mill in the Kelley Square area. This landmark home was demolished in 1959 for construction of Interstate 290. The Vernon Street on-ramp now occupies its place.

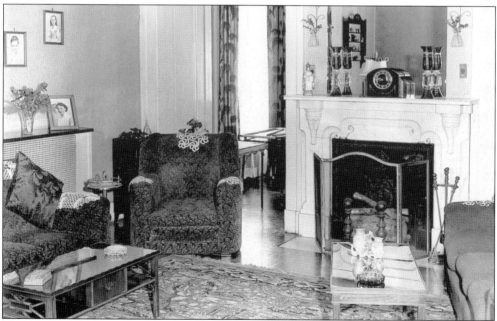

A Zabinski family photograph offers a rare glimpse of the interior of the former Fox mansion as it appeared in the early 1950s. The 16-room home was designed in England and built from imported lumber. The living room features one of its six marble fireplaces. A winding staircase also graced the two-story house.

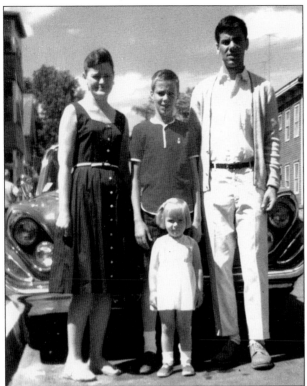

Helen Kasprzak stands with her sons, Paul and Tom, and daughter Jane in front of their 1962 Chrysler 300, parked in front of the family home on Washington Street. Behind them, the street runs north toward Kelley Square. They are facing the Lafayette Street intersection.

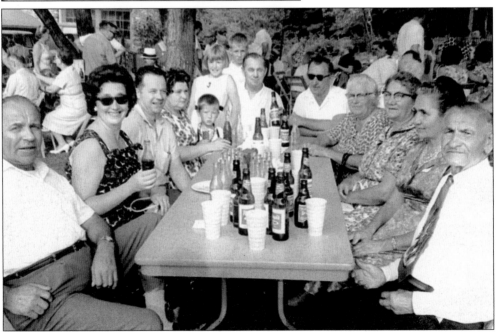

Shirley Starzec was the hostess of this informal Polish picnic, held at her Grafton home sometime in the 1960s. Pictured from left to right are unidentified, Zofia Gawronska, the Tarasiak family (Tadeusz, Marya, Robert, and Jane), and Kazimierz Gawronski. The other individuals are not identified.

Three

EARNING A LIVING

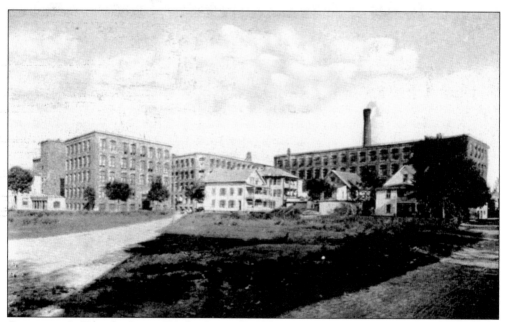

Crompton & Knowles Loom Works, located on Grand Street, was a dominant manufacturer in Worcester's 19th- and 20th-century industrial scene. Established in 1840, Crompton & Knowles produced textile machinery and looms for an extensive variety of woven fabrics. Jobs here supported countless Polish immigrant families.

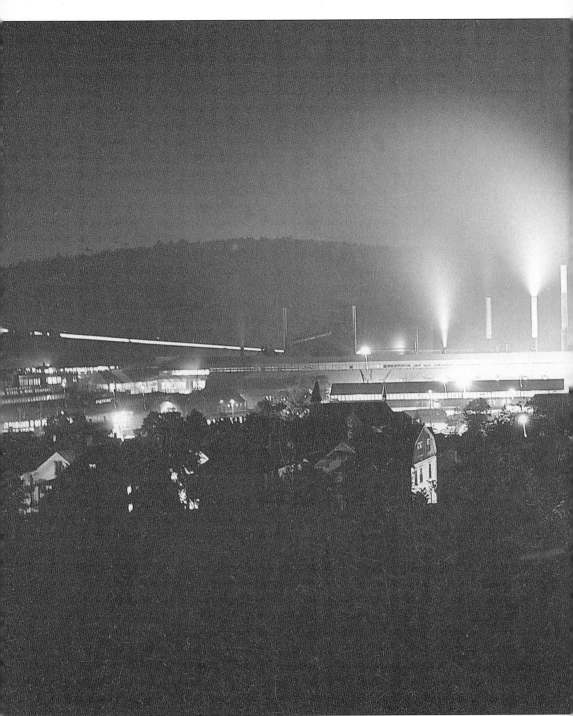

An otherwise dark night landscape shines bright with lights from second-shift work at the American Steel & Wire Company South Works at Millbury and Ballard Streets. Raymond Peterson made this photograph in 1939, setting up his camera on the back porch at 14 North Steele Street. High on Packachoag Hill in Quinsigamond Village, the location afforded a panoramic view of the brick mill. Wire rope from American Steel had a steady market, and the

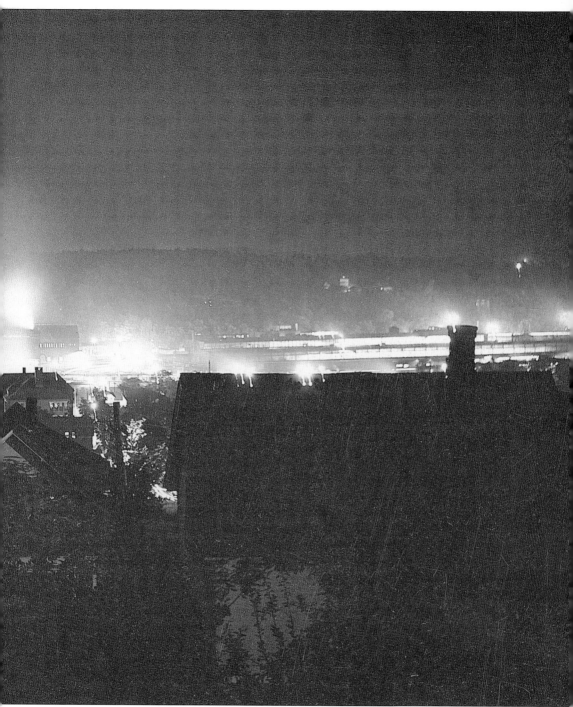

mill's products were particularly important to the U.S. effort in two world wars. Even in the 1950s, the whistle of the train that passed through the American Steel plant around 2:00 a.m. reminded Island and village residents of the mill's ceaseless activity. In its later years, the wire mill was operated by U.S. Steel Corporation.

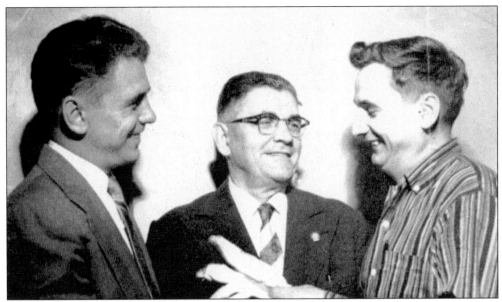

Edward Zaleski (right) passes on his work gloves to his brother Raymond (left) as their father, Alexander Zaleski, looks on. By the time this photograph was taken c. 1956, the three had logged more than 60 years of service at American Steel & Wire. Alexander began his job as a wire drawer at the South Works in 1926 and Edward at the North Works in 1941. Raymond, the younger brother, started at the North Works in 1942.

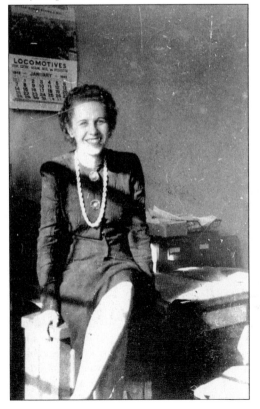

Josephine Proko, executive secretary to the president of Wickwire Spencer Steel Company, takes a break from her duties in January 1945. Wickwire, located near Webster Square, was one of several Worcester manufacturers deemed vital to the U.S. war effort in the 1940s. Their metal perforation products ranged from steel rope used for rigging Liberty ships to wire cloth used on destroyers and submarines.

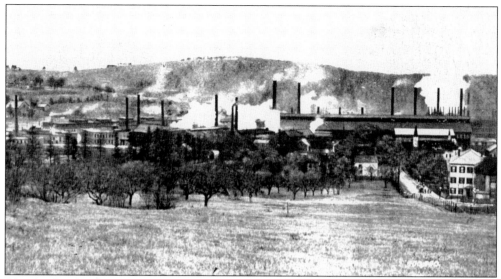

Clouds of smoke spew from some of American Steel & Wire's many stacks in this 1910-era postcard. Data recorded on World War I draft registration cards, as well as in the 1920 U.S. Census, identify the wire mill as the chief place of employment for Worcester's Polish immigrants. "Wire drawer" is the most common occupation listed. Work was hard and wages low in this category.

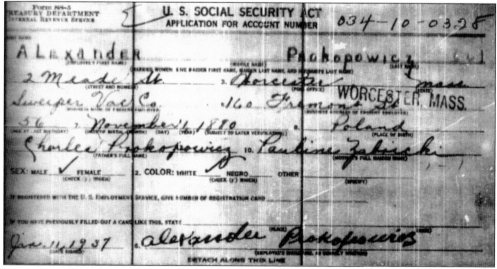

Regardless of whether they were aliens or naturalized citizens, immigrants were eligible to apply for a Social Security account when the federal program began in 1936. The form required birth date and place, as well as parents' names, making it a valuable source of genealogical data. Alexander Prokopowicz's application, filed in 1937, is the only U.S. document that identifies his mother's name.

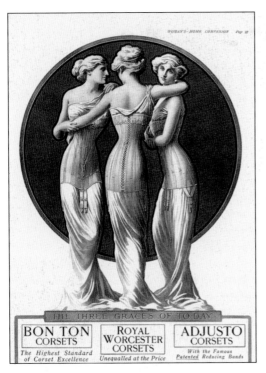

"The Three Graces of To-day" model undergarments produced by the Royal Worcester Corset Company in this October 1909 advertisement from *Woman's Home Companion*. At its factory on Grand Street, the company drew much of its labor from female immigrants. Although trolley lines ran throughout the city, Poles from the Island could not afford the daily cost and more often relied on walking to work.

Dressed for work, Stacia Prokopowicz (right) poses with her friend Ruth. After graduating from Millbury Street School *c.* 1933, the teenager got a job as a live-in nanny and housekeeper for a family in the Providence Street area. It was there that she met her future husband, Bernard Paskavitz, whose family owned the residence.

Helen R. Karolkiewicz wears a cap and gown signifying her graduation from the Massachusetts College of Pharmacy in 1931. The daughter of Lucian G. and Mary Wodzinski Karolkiewicz, she became the first female registered pharmacist in Worcester. Married to Boleslaw Zendzian, she owned and operated Main South Pharmacy from 1933 to 1971.

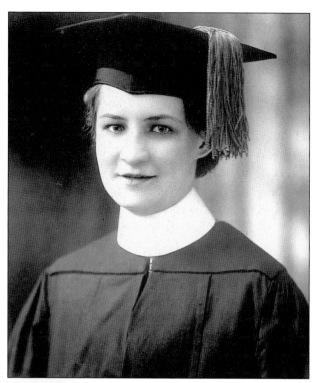

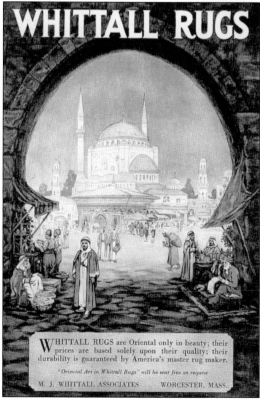

During the 1920s, high-quality woolen carpeting made M.J. Whittall Associates one of Worcester's top manufacturers. Although textiles ranked second to steel in the city's industries, textile mills were seen as the more suitable workplaces for women. Whittall's Southbridge Street location made it a convenient workplace for the city's Poles. After 75 years of production, the Whittall mill closed in 1957.

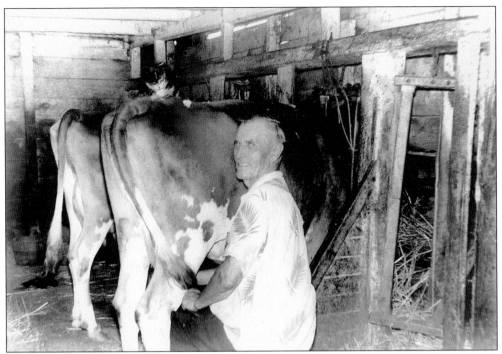

Alfons Sziatkowski milks one of the cows at his Pleasantdale Road farm in Rutland *c.* 1959. He sold his dairy products, such as milk and farmer's cheese, in Worcester.

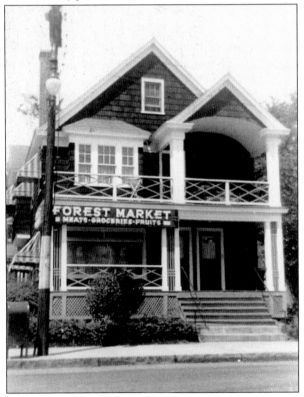

John Szlyk operated Forest Market, located at 549 Grove Street across from Indian Lake, for almost a half-century, from 1938 to 1982. The store served the Polish people of Worcester's west side. The grocery advertised meats and produce.

Four

BUSINESSES AND SERVICES

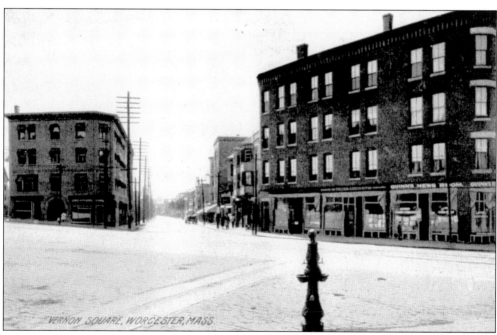

A two-spigot water fountain stands in the foreground of this early postcard view of Vernon Square, later renamed Kelley Square. The three-story building on the left is familiar as the Hotel Vernon, which was operated for many years by the McGady brothers. Millbury Street, the heart of Worcester's Polonia, begins at this square and runs south. The view is from the Water and Green Streets side of the square, with Vernon Street to the left of the hotel and Harding and Madison Streets to the right of the four-story building.

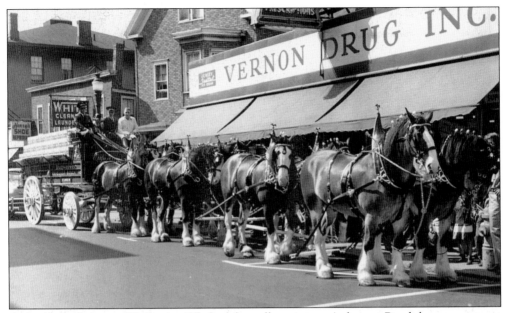

An eight-hitch team of Budweiser Clydesdales pulls a vintage Anheuser-Busch beer wagon past Buyniski's Vernon Drug on Millbury Street *c.* 1954. Seated to the right of two brewing company representatives is Stanley Kuczka. The event was a promotion for McGovern's Package Store at 82 Millbury Street. South of the drugstore are Dr. Mitchell Zadrozny's office, White's Cleaners, and Henry's Shoe Repair.

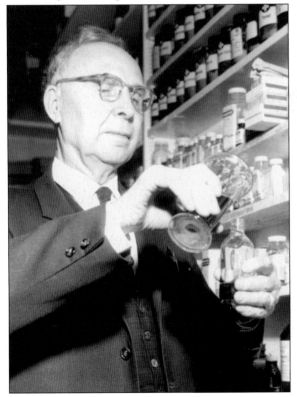

Pharmacist Joseph P. Buyniski measures out medicine to fill a prescription at Vernon Drug. The drugstore became a popular landmark at Millbury, Lafayette, and Harding Streets. It continued under family management through the 1980s, the flagship of a chain of Vernon Drugs in the Worcester area.

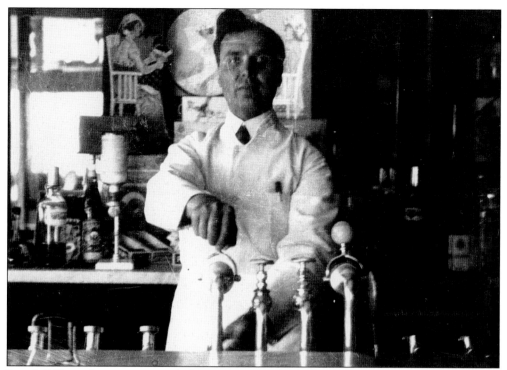

Joseph P. Buyniski serves up a soda-fountain treat in his early years as proprietor and pharmacist at Vernon Drug. Over the years, many students attending schools in the neighborhood gathered at the soda counter for an after-school ice-cream soda or raspberry lime rickey.

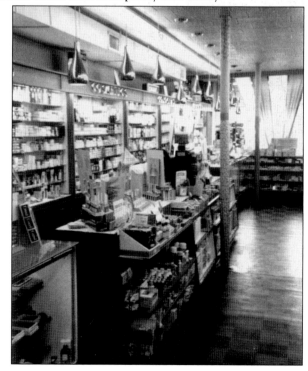

The cosmetics department at Buyniski's Vernon Drug features an array of beauty items available for sale in the early 1960s. The drugstore offered numerous products that conveniently met the needs of its neighborhood customers.

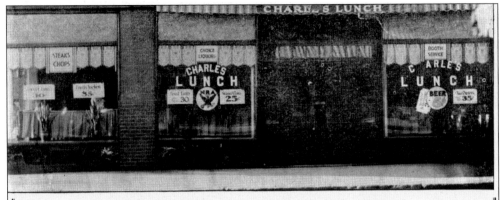

NAJWIĘKSZA POLSKA RESTAURACJA W CENTRUM MASS., POD FIRMĄ

CHARLES LUNCH

94-96 Millbury Street **Worcester, Mass.**

OPRÓCZ SMACZNYCH OBIADÓW PRZEKĄSEK, ZNAJDZIECIE TU LIKIERY Z POLSKI IMPORTOWANE I
EUROPEJSKIE PIERWSZEJ JAKOŚCI NASZĄ SPECJALNOŚCIĄ TUTEJSZE WÓDKI
(LEADING BRAND) JAK:
PAUL JONES — FOUR ROSES — FLEISHMAN GIN SCHLITZ PIWO I INNE
GNIAZDOWI 250 ŻYCZYMY DALSZEJ OWOCNEJ PRACY

KAZIMIERZ SZARAMETA

Członek Gniazda 250

Kazimierz Szarameta (Charles Sharameta) opened Charles Lunch in 1923 as a 14-stool lunch counter serving single, young wire mill workers who savored roast pork dinners for 20¢ and hearty, affordable five-sandwich bag lunches. By the 1930s, the eatery at Millbury and Lafayette Streets was the biggest Polish restaurant in central Massachusetts. In the 1950s, it established itself as a first-class seafood restaurant and steakhouse, with seating for 150. Politicians, athletes, entertainers, and other celebrities were among the regulars at this landmark until the property was razed for apartment construction in the 1980s.

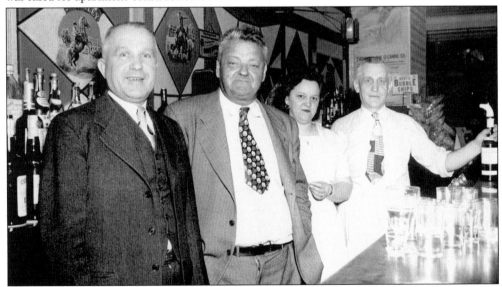

Behind the bar at Boris's café on Millbury Street, from left to right, are Charles Sharameta, owner Charles Boris, an unidentified woman, and Anthony Sharameta. Known earlier as Ed Smith's Restaurant, it became the Harding Café after Boris sold it and bought Chestney's Canteen at 90 Millbury Street.

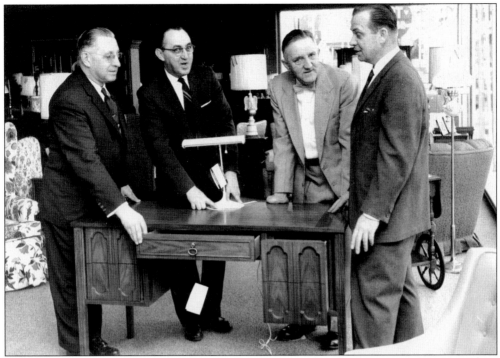

The men of Millbury Furniture gather to examine a new line of desks. From left to right are founder Andrew Gebski, his son Henry Gebski, Thure Dahlquist, and an unidentified person. Frank Mis was an early partner in the business, which had a reputation of carrying a complete line of quality home furnishings. (Reprinted with permission of the *Worcester Telegram & Gazette*.)

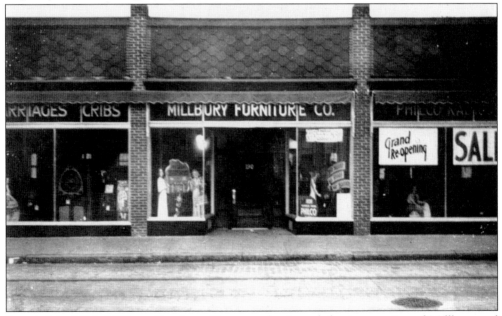

Founded in 1926, Millbury Furniture Company dominated the intersection of Millbury and Endicott Streets for 50 years. For decades, streetcars ran regularly through this busy shopping district. Millbury Street was later paved and restricted to northbound one-way traffic.

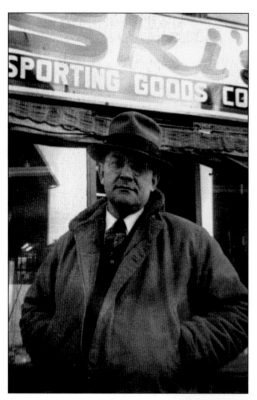

Alexander J. Zaleski stands in front of Ski's Sporting Goods Company at 130 Millbury Street shortly after his son, John D., opened the store in 1946. Originally located next to George's Fruit Store, Ski's moved in 1947 to larger quarters directly opposite, on the corner of Taylor Street, and stayed in business until 1956. Ski's offered a wide variety of hunting and fishing gear and specialized in reel repairs and fly tying. Neighboring businesses were Ida Goodwin's dry goods store and Wong's laundry.

Small newspaper advertisements were the norm for the Rialto, located at 37 Millbury Street. In the 1920s, a dime covered a child's 6¢ admission, with 4¢ to spare for candy. The neighborhood theater catered to its immigrant working class with regular promotions such as the "Free Cannon Linen to Ladies Tomorrow," offered in the top ad. "Dish night" provided low-cost table settings for many new Americans' homes.

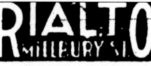

RIALTO
MILLBURY ST.
MON. AND TUES.
RUDY VALLEE
And His Connecticut Yankees in
"THE VAGABOND LOVER"
CO-FEATURE
"THE GOLDEN CALF"
with JACK MULHALL, SUE CAROL
EL BRENDELL, MARJORIE WHITE
Free Cannon Linen to Ladies Tomorrow

RIALTO
THEATER
Millbury Street, Near Vernon Square
TODAY
AGNES AYRES and JACK HOLT
in
"Bought and Paid For"
Amateurs Tonight With Vaudeville

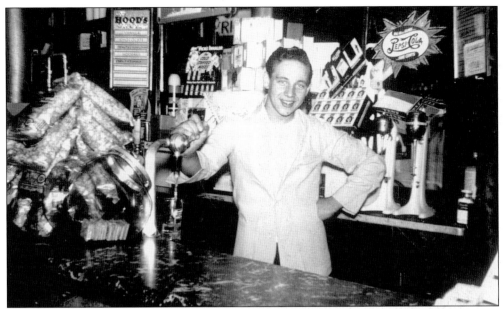

Thaddeus Golas is ready for action at a part-time job that any high school student might envy. He is pictured here in 1944 at the soda fountain of Zendzian's Drug Store. Operated by Boleslaw P. Zendzian at 111 Millbury Street, the establishment was across the street and a few doors north of its counterpart, Buyniski's.

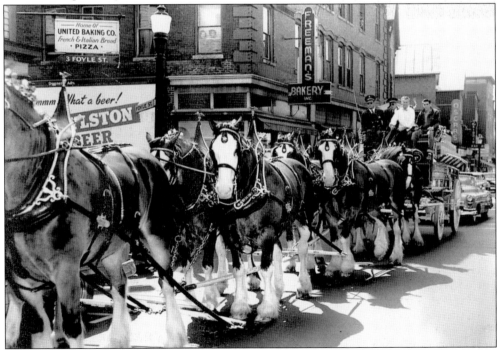

McGovern's Package Store manager Robert Largess holds the reins of a Budweiser Clydesdale team pulling a 1905 Anheuser-Busch beer wagon along Millbury Street *c.* 1954. The beer wagon is passing Foyle Street and Freeman's Bakery, which were demolished during Interstate 290 construction in 1959. Visible a few doors down are Oscar's Cleaners and Kiddie Kastle.

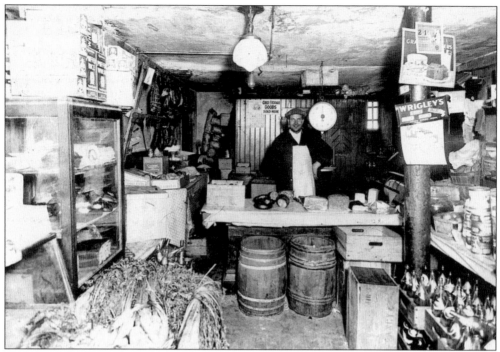

Teofil Wondolowski stands behind the counter of his market in May 1923. The store was in operation at 15 Winter Street for more than a decade, followed by a joint venture at Perry Avenue and Seymour Street. A final move to Vernon and Upsala Streets prompted a name change to Eklund Square Market. Here, Wondolowski's sons, Joseph and Walter, continued the family business into the 1980s.

Jedyna Polska Browarnia
Na Całą Nową Anglję

Słynne

Brockert's Ale

BROCKERT BREWING CO.

WORCESTER, MASS.

"The only Polish brewery in all of New England" is how the Brockert Brewing Company described itself in this 1939 advertisement in the Polish-language newspaper *Kuryer Codzienny*. Brockert's office was at 60 Ellsworth Street and its plant at 81 Lafayette Street.

STANLEY'S FRUIT STORES

650 MAIN ST. Opposite Hadley's 130 MILLBURY ST.

FRIDAY and SATURDAY SPECIALS

California CARROTS	2 Bchs. 13c	Fancy Pascal CELERY	Big Bch. 21c
Fancy Yellow ONIONS	Lb. 4c	Extra Sweet Florida ORANGES	Doz. 31c

This advertisement for weekend specials at Stanley Blasko's two fruit stores appeared in a Worcester newspaper on April 13, 1945. When Millbury Street was in its heyday, virtually every block offered shoppers their choice of greengroceries, bakeries, meat and fish markets, and candy stores. The aromas of fresh fruit, sausage, rye bread, and sweet treats wafted from many doorways.

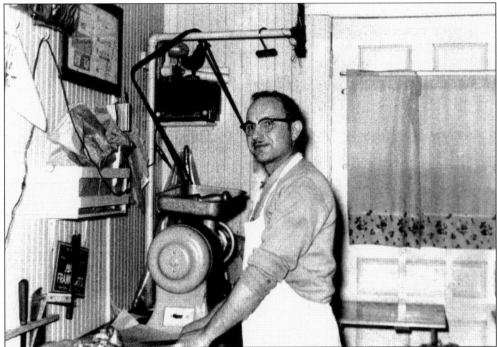

Albert Hryniewicz works at the meat grinder at Lafayette Market, making his specialty, fresh kielbasa, from his own recipe. Located at the corner of Lafayette and Grosvenor Streets, the store was in the heart of one of Worcester's two most densely Polish neighborhoods. Brothers-in-law Hryniewicz and Boleslaw Linga co-owned the market from 1945 to 1956. Hryniewicz and his wife, Helen, then operated the store until 1970.

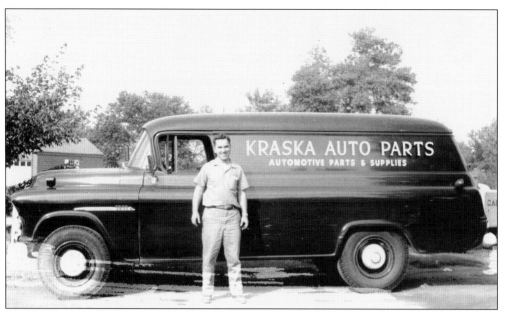

Pictured in 1960 in front of his Chevrolet truck, John J. Kraska Sr. gets ready to deliver automotive parts to one of his customers. Kraska started the business in 1954. It was located at the Water Street intersection with Fox Street until 1960, when it moved to 878 Millbury Street.

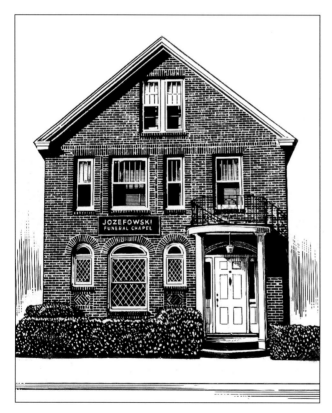

An artist's sketch depicts the brick building that housed Józefowski Funeral Chapel at 52 Ward Street. Alexander J. Józefowski originally opened the business at 316 Harding Street.

Five

THE SOUL OF POLONIA

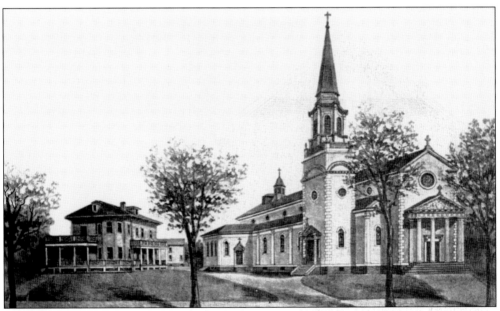

An artist's sketch depicts the 750-seat Our Lady of Czestochowa Church and rectory shortly after the facilities were completed in 1906. To the right rear of the rectory is the schoolhouse where religious instruction was offered. Joseph Reglinski designed much of the architecture; the Springfield Diocese awarded McDermott Brothers the construction contract. Rev. Jan Z. Moneta oversaw the project. The congregation had paid off a third of the $54,000 cost by the time the church opened.

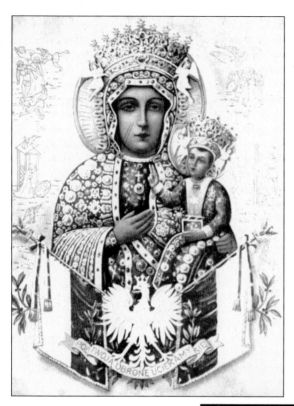

When Worcester's immigrant Poles founded their own parish in 1902, they named it in honor of Our Lady of Czestochowa. Tradition holds that St. Luke painted this particular image of the Virgin Mary on a cypress tabletop used by the Holy Family of Nazareth; the dark wood led the image to be known as the Black Madonna. The painting arrived in Poland in the 10th century. Since 1717, Our Lady of Czestochowa has been designated as the patroness and queen of the Polish nation.

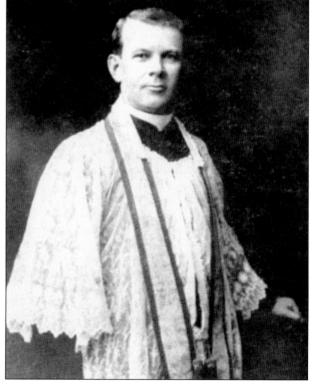

The Reverend Jan Z. Moneta was the Polish community's first resident pastor, arriving in September 1903. Moneta was instrumental in founding the parish's Rosary Society and Children of Mary, expanding St. Cecilia's Choir, establishing local chapters of the Polish Roman Catholic Union and Polish National Alliance, and supporting the organization of the Polish Political Club. He died of cancer at age 44 in July 1907, just months after Our Lady of Czestochowa Church opened.

Msgr. Boleslaw A. Bojanowski, the fourth pastor of Our Lady of Czestochowa Parish, served Worcester's Poles for an unparalleled 41 years. From his arrival in 1913 to his retirement in 1954, Bojanowski's intelligence, interests, and values made him the community's intellectual, cultural, and political leader, as well as its spiritual guide. He is pictured here c. 1940.

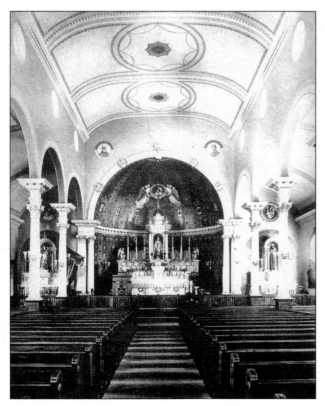

A photograph shows the interior of Our Lady of Czestochowa Church, which opened on the Feast of the Assumption, August 15, 1906. The long-awaited event was the culmination of fund-raising that had begun in 1900, a Richland Street land purchase in 1901, the official parish founding in 1902, the arrival of the community's first resident Polish priest in 1903, and the construction that began in 1905.

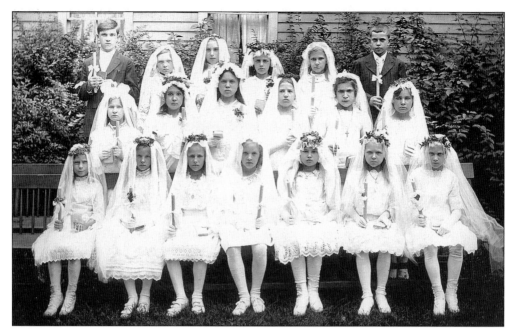

Holding candles, prayer books, and rosaries, these youngsters are dressed for First Communion *c.* May 1917. Traditional floral wreaths adorn the girls' long white veils. In that era, children typically received the sacrament at about age 10. Identified in the middle row, far right, is Pauline Prokopowicz.

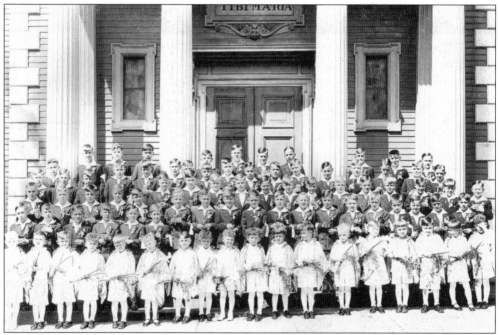

More than 60 boys fill the steps of St. Mary's in this 1933 First Communion photograph. Contrasting with the older boys in their dark jackets and wide-collared shirts, the younger boys (front row) wear white outfits topped with capes. Holding lilies, they probably preceded the communicants in a procession down Richland Street from the school to the church.

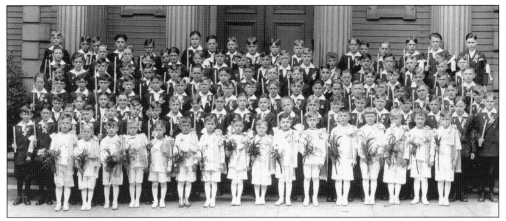

Nearly 100 boys making their First Communion, along with younger attendees, are pictured in 1930 on St. Mary's Church steps. The number of children in the parish was at its peak in these years, as many of the young immigrants who had settled in Worcester married and began raising large families.

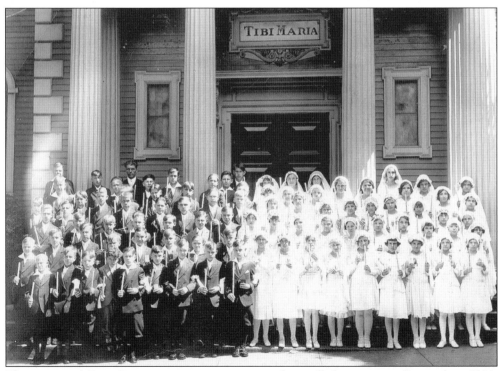

This group of First Communicants is comparatively small for its time. Pictured *c.* 1931, these young parishioners may have attended the Island's public schools. St. Mary's School Communion photographs from the era are typically double this size. The second girl from left in the first row is identified as Vitella Prokopovich, a student at Millbury Street School.

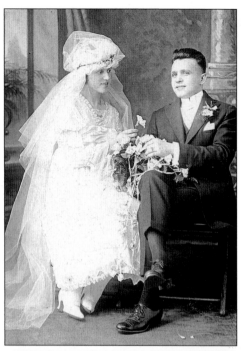

A bridal bouquet serves as a focal point in this studio portrait of Franciszka Gryszkiewicz and Kazimierz Szarameta, who were married at Our Lady of Czestochowa Church c. 1918. The couple later Americanized their surname to Sharameta.

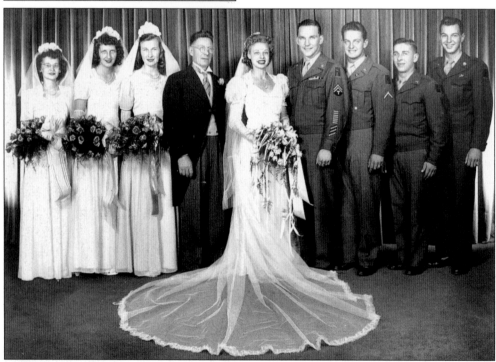

Military uniforms replace formal wear for the men in this August 1946 wedding party. Pictured from left to right are bridesmaids Rita Karpowich, Ann DeSavage, and Pola Pszykowska; Paul Skowronski, father of the bride; the bridal couple, Irene Skowronska and Anthony Kirvilaitis; and ushers John Kowski, William Szlyk, and Edward Michelski. The wedding took place at St. Mary's Church.

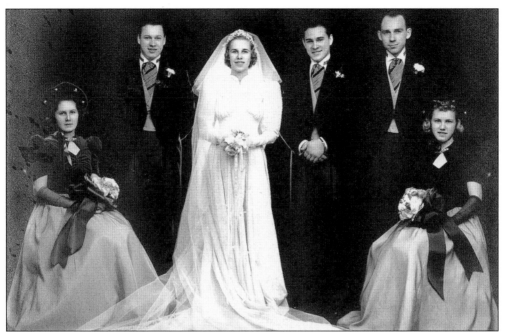

Alphonse D. Prokopovich, Josephine B. Prokopowicz, and their attendants pose prior to the couple's November 9, 1940, wedding at St. Mary's. Pictured from left to right are Irene Londergan, the bride's niece and maid of honor; Julius W. Prokopovich, the groom's brother; the bride and groom; Peter Lavich, best man; and Albina R. Zybas. The wedding reception was held at the Hotel Vernon. Julius Prokopovich and Albina Zybas were wed at Our Lady of Vilna Church in 1942.

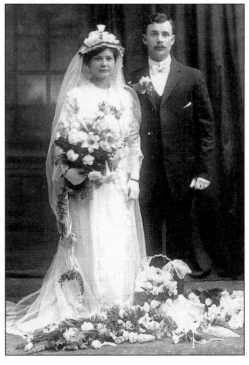

With flowers artfully covering the hem of her wedding gown, bride Michalina Gajzder stands next to her groom, Jan Pieniazek. They were married at St. Mary's on February 9, 1915. White roses, which symbolize love, and long thin ribbons knotted to hold sprigs of rosemary, for fidelity, were popular elements in traditional Polish bridal bouquets.

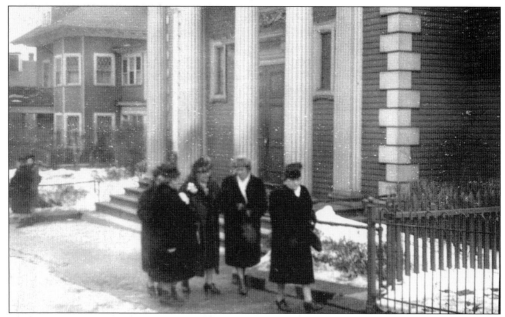

Several women, dressed for winter, share a conversation as they walk past St. Mary's Church c. 1947. The rectory is visible to the left on Richland Street. Until Interstate 290 altered the landscape, Richland Street made the church accessible to walkers from Vernon Hill and Millbury Street alike.

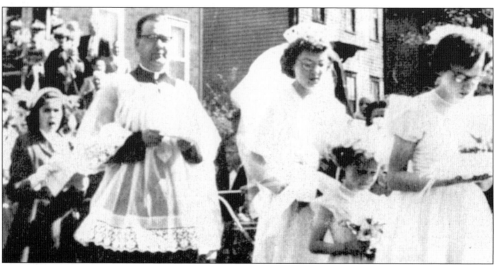

Attendants lead Rev. Casimir Swiacki and Marie Rembiszewska and toward the church shrine for the parish's first annual coronation of the Blessed Virgin in May 1952. Hundreds of parishioners filled Richland and Ward Streets for these joyous May processions, celebrated with flowers and traditional Polish hymns, such as "Serdeczna Matko" and "Po Górach Dolinach."

The Reverend Charles J. Chwalek, shown here blessing his congregation, became the fifth pastor of Our Lady of Czestochowa in February 1956. He undertook extensive renovation of the parish complex, which was greatly complicated in 1959–1960 by Interstate 290 construction. Chwalek was named a monsignor in March 1961. He retired in June 1976 due to failing health and died that October.

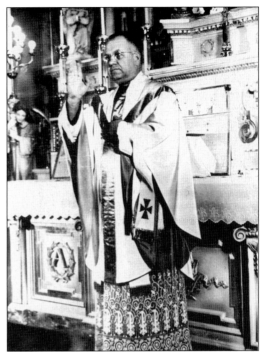

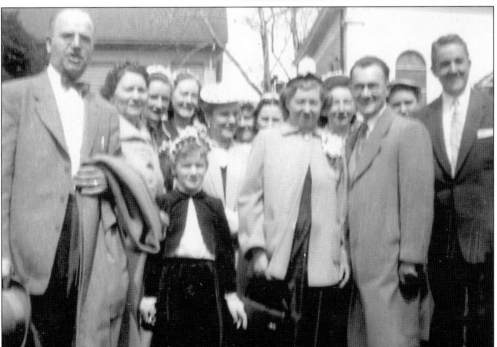

Members of St. Cecilia's Choir join their organist's family for a photograph. In the foreground, from left to right, are Stanislaus G. Wondolowski, Helen Musiol, Gertrude DeWitt, organist Adolf Musiol, and Dr. Steven Starr. Rose Musiol, wearing a light-colored hat, stands behind her daughter. The building in the left background is the original wooden school where religious instruction was offered before St. Mary's School opened. The church is on the right.

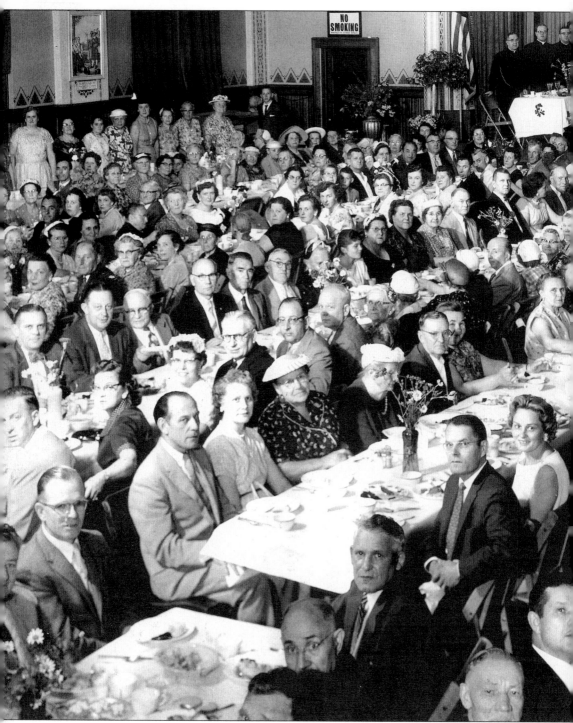

A testimonial dinner on June 21, 1959, honored Rev. Anthony Nasiatka on the 35th anniversary of his ordination to the priesthood. "Father Tony" stands on the left center at the head table, with Rev. John Szamocki third on the left and the Reverend Charles J. Chwalek sixth on the left. The event, held at St. Mary's High's Kosciuszko Auditorium, attracted more

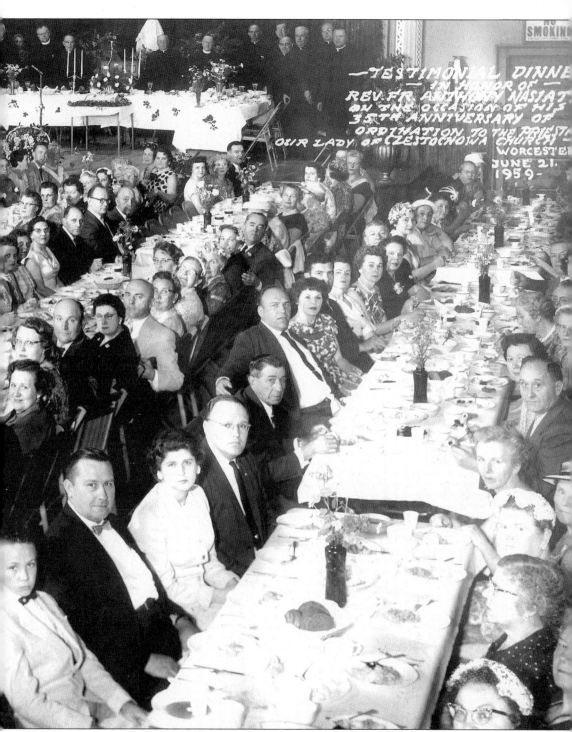

In the photograph, text reads:

—TESTIMONIAL DINNER—
IN HONOR OF
REV. FR. ANTHONY NASIATKA
ON THE OCCASION OF HIS
35TH ANNIVERSARY OF
ORDINATION TO THE PRIEST-
OUR LADY OF CZESTOCHOWA CHURCH
WORCESTER
JUNE 21.
1959.

NO SMOKING

than 500 well-wishers. Nasiatka was born in 1897 in Russian Poland to a family that settled in Worcester. He attended SS. Cyril and Methodius Seminary in Orchard Lake, Michigan. In his long career at Our Lady of Czestochowa Parish, Nasiatka was well loved for his quiet, kind demeanor. His duties included teaching religion classes at St. Mary's High School.

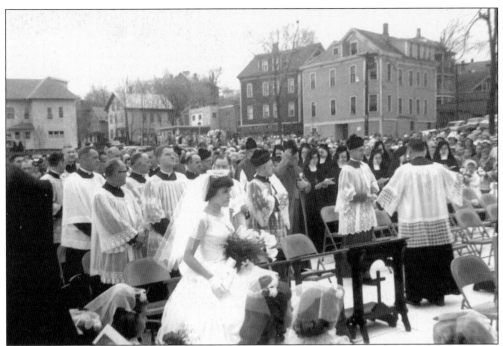

Hedy Bonder, incoming prefect of St. Theresa's Sodality, approaches the new Shrine of Our Lady of Czestochowa for the traditional coronation of Mary on May 7, 1961. Designed by Msgr. Charles J. Chwalek and dedicated by him that day, the new shrine was erected to the south of the church. It replaced a smaller one on the east side, which was demolished in conjunction with expressway construction.

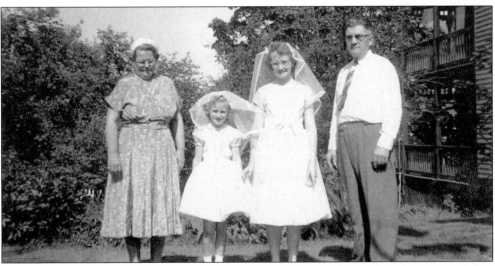

May 29, 1960, was the day that Karen Jasukonis was accepted into St. Theresa's Sodality, an organization that promoted devotion to the Blessed Virgin Mary. Jasukonis and her older cousin, Ilene Zaleski, wear the white veils that identified sodalists at Mass and May processions. The girls are flanked by their grandparents Michalina and Alexander Zaleski.

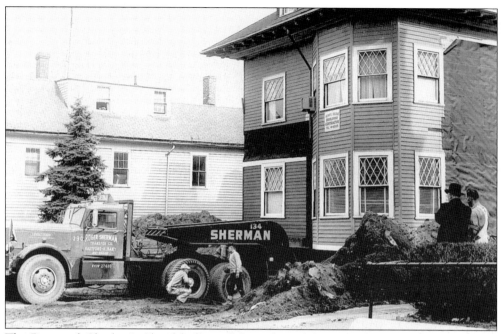

The Reverend Charles J. Chwalek (second from the right) and building contractor Henry J. Recko watch from the side yard as the parish rectory is positioned on a flatbed to be moved from 15 Richland Street around the corner to 34 Ward Street in the spring of 1959. Construction of Interstate 290, locally known as the Worcester Expressway, forced the relocation.

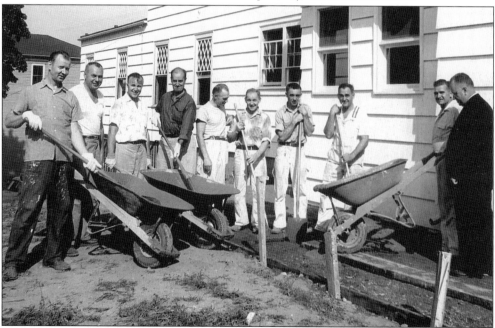

Workers stand ready with shovels and wheelbarrows when the time comes to fill in around the rectory's new foundation. Standing from left to right are Chester Lewandowski, Mitchell Kwiatkowski, Edward Gorak, Walter Poltorak, Chester Blaszczyk, Tadeusz Folta, Francis Vigeant, contractor Henry Recko, John Kwiatkowski, and the Reverend Charles Chwalek.

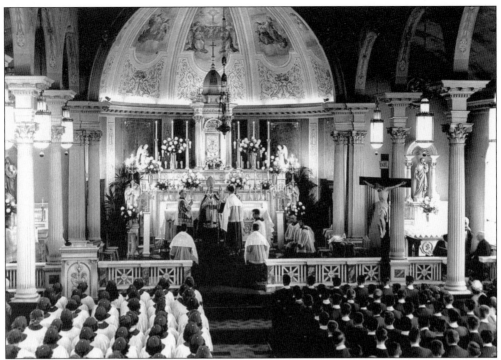

The Most Reverend Bernard J. Flanagan, bishop of Worcester, officiates at confirmation services at Our Lady of Czestochowa Church on October 22, 1960. More than 120 St. Mary's High School freshmen and other parishioners received the sacrament that day.

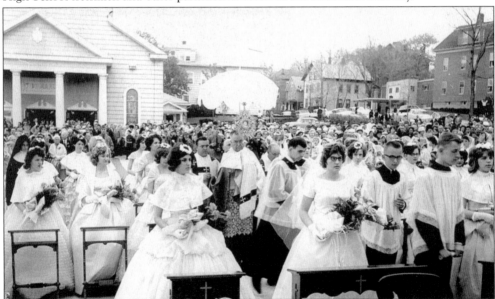

Wearing the traditional white veil and gown, incoming sodality prefect Frances Boronska prepares to place a bouquet of flowers before the statue of Mary during the 1963 May procession. Standing on the left is Helen Eddy, vice prefect. Protected by an umbrella, a monstrance containing a consecrated Host is held high by Msgr. Charles Chwalek. Parishioners filled the new Czestochowa Square to capacity.

Six

ST. MARY'S SCHOOLS

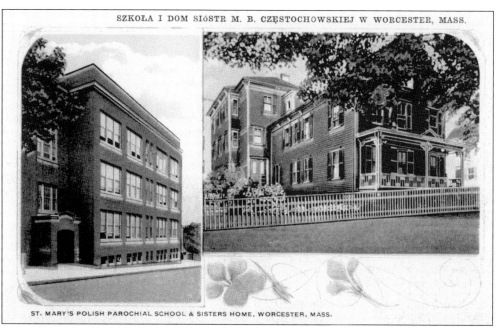

SZKOŁA I DOM SIÓSTR M. B. CZĘSTOCHOWSKIEJ W WORCESTER, MASS.

ST. MARY'S POLISH PAROCHIAL SCHOOL & SISTERS HOME, WORCESTER, MASS.

An early postcard offers views of St. Mary's School at 50 Richland Street and the convent of the Sisters of the Holy Family of Nazareth at 119 Endicott Street. The three-story brick school opened in September 1915, with a two-story wing added on the south end in 1920. A second addition, with another eight classrooms, a gymnasium, and Kosciuszko Auditorium, was completed in June 1928.

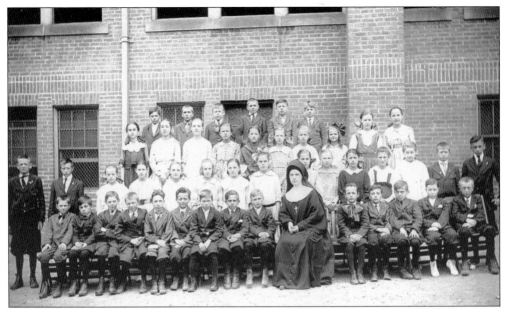

St. Mary's School fifth-graders and their teacher, a Holy Family of Nazareth nun, pose for a photograph in the schoolyard in 1918. St. Mary's opened in September 1915. By 1921, the Polish elementary school had grown to be the largest of 35 parochial schools in Worcester County.

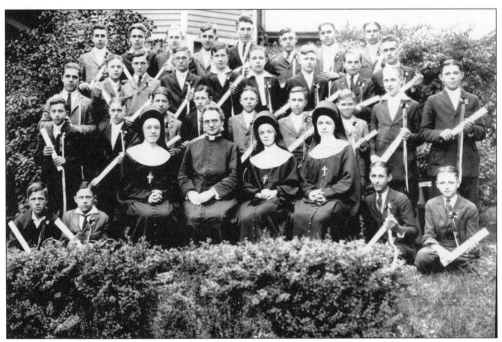

The Reverend Boleslaw Bojanowski and three unidentified Sisters of the Holy Family of Nazareth pose with 30 eighth-grade boys graduating from St. Mary's School in June 1923. The boy in the back row on the far right is Joseph Stanley Prokopowicz. The group is gathered in front of the rectory on Richland Street. The photograph was made by the Kula & Kuzmicki Photo Studio of 156 Green Street.

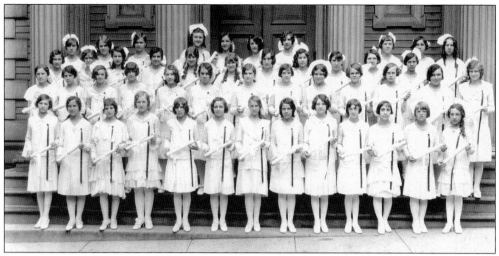

Long ribbons affixed to their white dresses, along with diplomas, identify these girls as graduates of St. Mary's School. Many of the boys wear long pants, a more grown-up style than knickers. The groups pictured here are a fraction of the total number of eighth-graders completing their St. Mary's School education in 1929. Total enrollment at the school exceeded 1,200 the prior year, when the second of two additions opened to students.

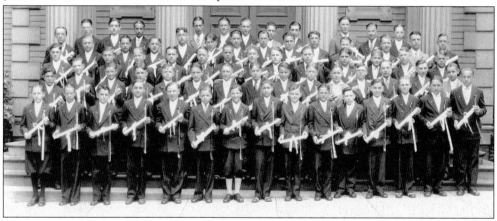

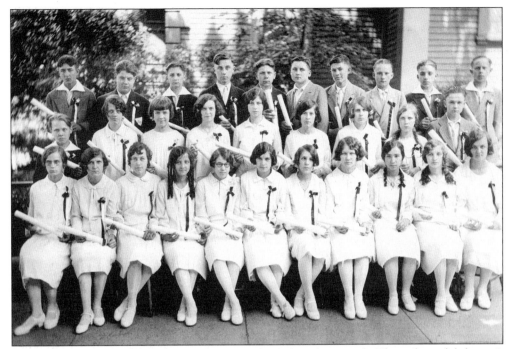

Some 1927 graduates of St. Mary's School pose for a class photograph. The girls model the era's range of popular hairstyles: short bobs, marcelled waves, and long baloney curls. Fewer options existed for the boys, who sport simple, neatly combed cuts.

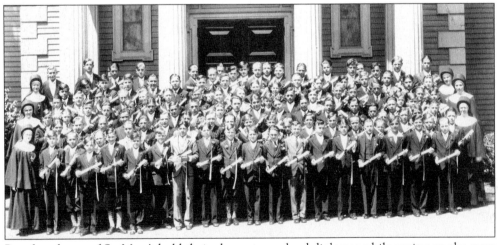

Proud graduates of St. Mary's hold their elementary school diplomas while posing on the steps of St. Mary's Church in 1932. Six Sisters of the Holy Family of Nazareth flank the graduates. John D. Zaleski is the third boy from the left in the second row.

A 1940 report card for Helen Glowik, a student in the first graduating class of St. Mary's High School, reveals high grades in a full range of academic subjects: Christian doctrine, Church history, English, Latin III, Polish, history, general science, and law. The young woman earned A's for conduct and effort. Her overall grades show her to be an honor student.

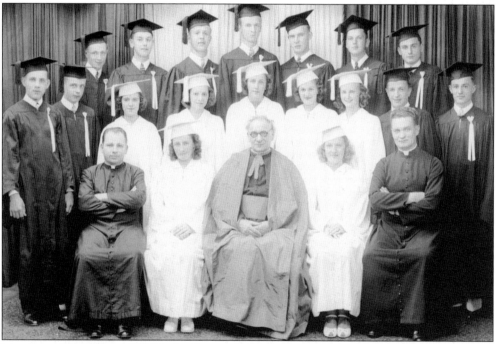

Members of the Class of 1940, the first to graduate from St. Mary's High School, pose with the parish priests. From left to right are the following: (front row) Rev. Wladyslaw Radzik, Helen Raymond, Msgr. Boleslaw Bojanowski, Sally Sklarz, and Rev. Jan Mieczkowski; (middle row) Zenon Sosnowski, Thaddeus Burzynski, Helen Glowik, Jane Rokoszak, Rose Krzyzewska, Alfreda Naleska, Eleanor Plona, Steve Kaczynski, and Vincent Choinski; (back row) Joseph Domkowski, Richard Gralicki, Chester Mietkiewicz, Clifford Butrym, Henry Ozimek, Walter Wondolowski, and Edward Zaleski.

Chester Janczukowicz, dressed in costume for a June 1940 play, stands in the schoolyard at St. Mary's. He graduated from St. Mary's High in 1941, entered the priesthood, and returned to the parish as a curate in 1954. "Father Chet," as Rev. Janczukowicz was familiarly known, was actively involved with the parish's youth groups over the next 12 years, serving as St. Mary's High athletic director and Catholic Youth Conference chaplain.

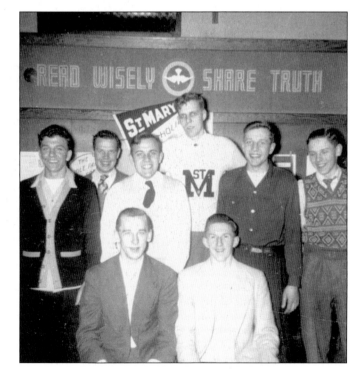

Boys in the 1949 senior class line up against a classroom blackboard that displays a St. Mary's pennant. From left to right are the following: (front row) Charles Recko and and Ray Kosciuszko; (back row) Francis Naumiec, Teddy Kosciuszek, Henry Kimbar, Henry Butkiewicz, Francis Lopato, and Edward Murawski.

Some St. Mary's High juniors visit with Msgr. Boleslaw Bojanowski on ring day on February 2, 1950. Standing from left to right are Jane Mysliwiec, Barbara Szczepanek, Stanley Stodulski, Henry Kalinowski, and Irene Sabacinska. New class rings are visible on Mysliwiec's and Sabacinska's hands.

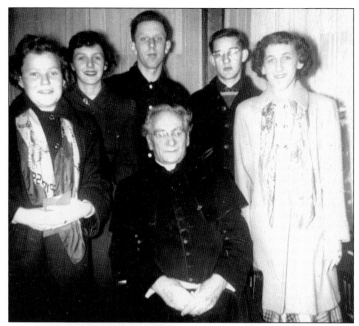

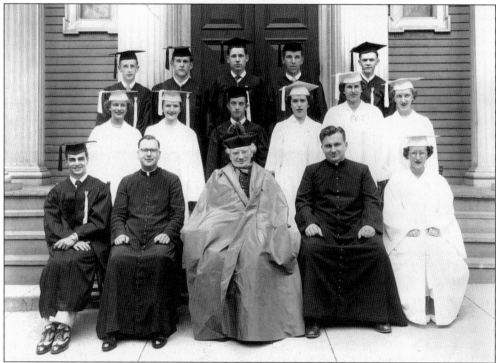

The priests of Our Lady of Czestochowa Parish join the 1952 graduates of St. Mary's High School for a portrait in front of the church. Pictured from left to right are the following: (front row) Ronald Pepka, Rev. Casimir Swiacki, Msgr. Boleslaw Bojanowski, Rev. Edward Kuzawa, and Irene Szypkowska; (middle row) Marion Stomski, Barbara Ciborowska, Chester Makowiecki, Statia Kotomski, Florence Blaszko, and Joanne Karbowski; (back row) John Murphy, John Lewandowski, Peter Naumnik, Richard Konopka, and Thaddeus Krawczynski.

Sr. M. Benjamin's first-graders pose for a 1952–1953 class picture. Born in 1946–1947, these students ushered in the post–World War II baby boom at St. Mary's. With two rooms of first-graders totaling almost 100 students, they would continue to be the largest class the school had witnessed since the peak post-immigration years of the 1920s. As the St. Mary's High Class of 1964, they ultimately numbered 76. Throughout the 1950s, the elementary homerooms typically had 35 to 40 students each. Some 18 nuns served as the staff and administration for the kindergarten-through-eighth-grade program. These Sisters of the Holy Family of Nazareth were members of the second largest order of Polish teaching nuns in the United States.

Sr. M. Bronislaus joins her first-graders in their 1952–1953 class photograph. Along with the baby boom, the postwar Displaced Persons Act caused enrollment to soar at St. Mary's in the early 1950s as more than 300 Polish families found new homes in Worcester. Angular cropping along the bottom of this photograph is due to its use in the 1953 St. Mary's High yearbook, which included coverage of the elementary school.

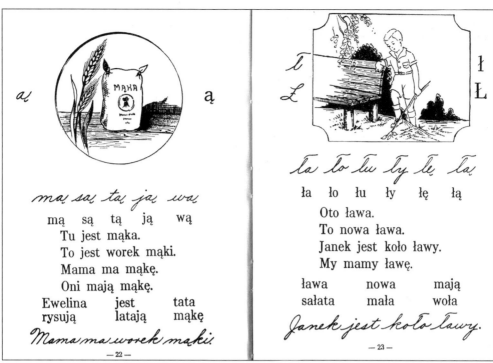

ai sai tai jai wai

mą są tą ją wą
Tu jest mąka.
To jest worek mąki.
Mama ma mąkę.
Oni mają mąkę.

Ewelina jest tata
rysują latają mąkę

Mama ma worek mąki.

— 22 —

Ła Ło Łu Ły Łę Łą

ła ło łu ły łę łą
Oto ława.
To nowa ława.
Janek jest koło ławy.
My mamy ławę.

ława nowa mają
sałata mała woła

Janek jest koło ławy.

— 23 —

For many years, *Moja Pierwsza Ksiazeczka* (*My First Little Book*) was the text used to teach first-graders Polish at St. Mary's School. These pages illustrate two of the Polish alphabet's distinctive letters. "A" with an ogonek, or tail, has a nasal sound, somewhat like "own" in English. "L" with a bar is pronounced like the English "w" in "water."

Joyce Eddy, with an eighth-grade graduation ribbon pinned to her dress, poses with Sr. Mary Xavier in the spring of 1954. Visible in the background is the church rectory in its original Richland Street location. The graduate was the daughter of Harold and Helen Eddy.

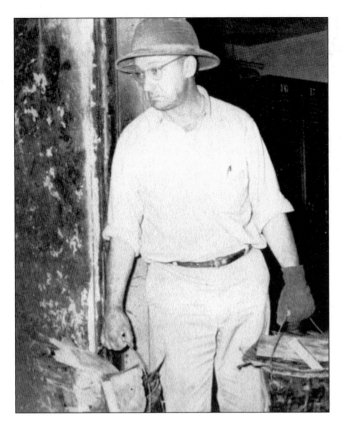

Francis Goicz carries out pails of debris from the fire-damaged boys' shower and dressing room at St. Mary's High School. A roaring two-alarm blaze early on Saturday morning, October 3, 1959, caused extensive damage to the high school stairwell and four classrooms, sweeping from the basement-level gym up through three floors to the roof. Goicz was among the many parishioners who volunteered for cleanup duties at the site.

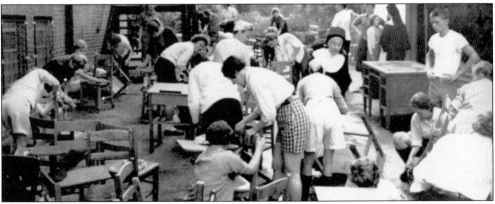

Parents, teachers, students, and parish volunteers all pitch in to clean up classroom furniture that was damaged by smoke in one of the two fires that struck the school complex in 1959. The second, on November 21, damaged the elementary wing. Some areas of the schools opened within two weeks; others remained closed until January.

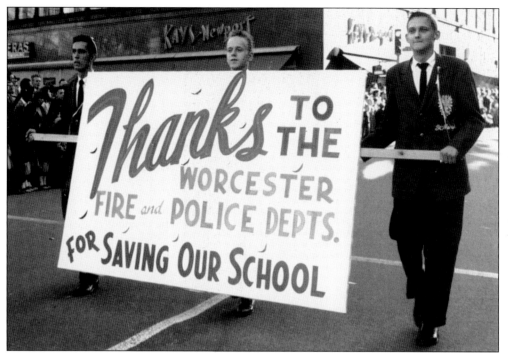

St. Mary's High students express their gratitude to the public safety crews who responded to the fall 1959 fires. Carrying a banner in the Catholic Youth Conference parade are, from left to right, Bob Baniukiewicz, Danny Siemaszko, and Ray Lojko. Catholic schools from throughout the Worcester Diocese took part in the parade along Main Street.

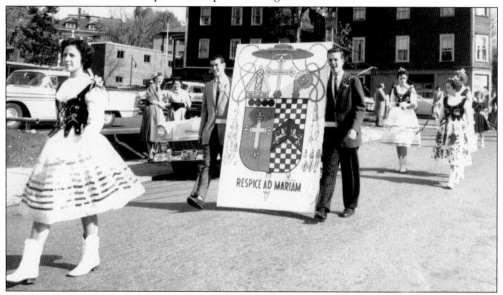

Pat Recko leads some St. Mary's High marchers down Richland Street en route to the Catholic Youth Conference parade. Behind her, Stanley Wondolowski (left) and Chester Jankowski carry a depiction of the coat of arms of Worcester Bishop Bernard J. Flanagan. It was painted by St. Mary's High student Chester Dymek. The school's cheerleaders and drill team also represented the school in the annual parade.

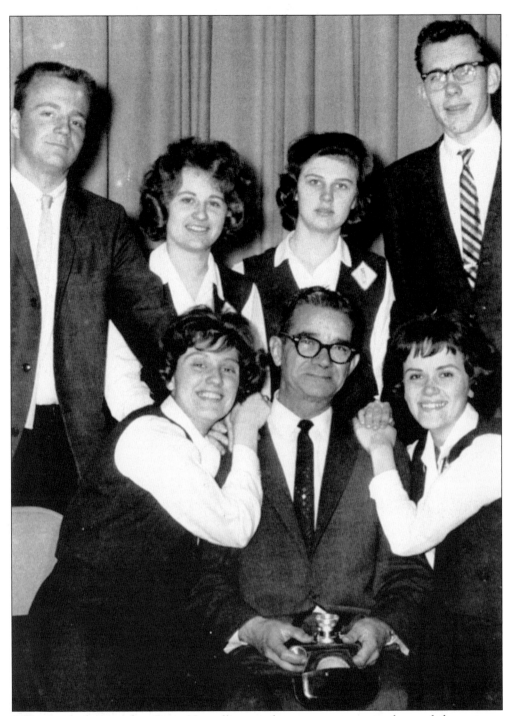

Professional photographer Peter Nappellio spends a rare moment in front of the camera, surrounded by the 1962 *Ave Regina* yearbook staff. Nappellio documented Worcester's Polish community for approximately 15 years, beginning in the late 1950s. With him, from left to right, are the following: (front row) seniors Barbara Debs and Hedy Bonder; (back row) Edward Jakubiak, Christine Hmura, Ann Menn, and John Bartosiewicz.

Henry Kolakowski, a longtime school custodian, sets up a projector to prepare a film for student viewing in the late 1950s. Kolakowski's mechanical and construction skills served the school and students well for many years.

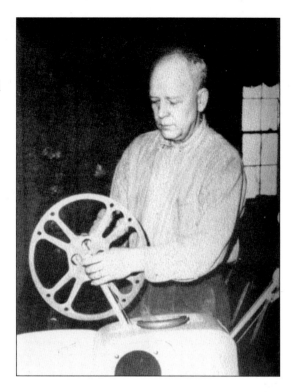

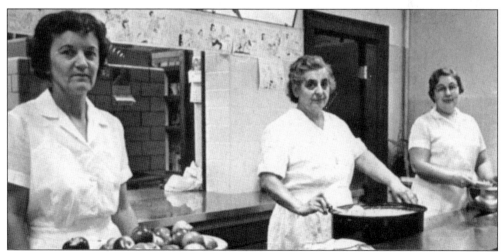

Ready to serve lunch is St. Mary's cafeteria staff. From left to right in this 1962 photograph are Mary Kolakowska, Josephine Gierczak, and Mary Grigas. The women, assisted by student aides, provided meals for hundreds of students every day.

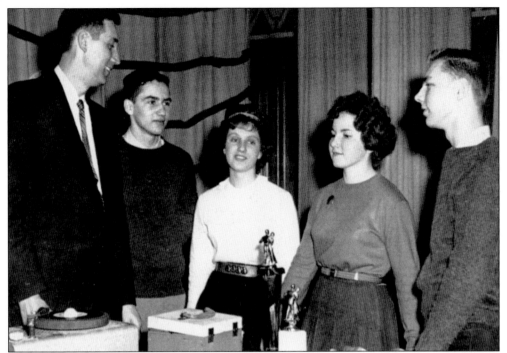

WORC-AM disc jockey Dick "the Derby" Smith (left) talks with students during a 1961 record hop at St. Mary's High. Pictured with him, from left to right, are Chet Dymek, Barbara Debs, Elaine Dymek, and Pete Zinkus. St. Mary's held record hops every Saturday night, with Smith at the turntable. Open to the public, the dances attracted hundreds of teens citywide. Smith is recognized as the first American disc jockey to play the Beatles on the air; in appreciation, the Beatles gave Smith their gold record for "She Loves You."

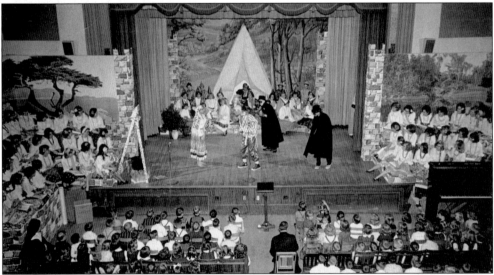

A balcony view of Kosciuszko Auditorium shows actors rehearsing at center stage for the 1964 St. Mary's High School senior class play, *The White Gypsy*. Elementary school students are seated to watch. The sizeable glee club, lining both sides of the stage, also played a role in the school's annual production.

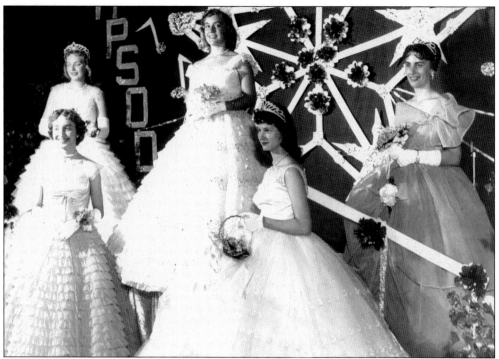

The queen of the 1959 senior prom and her court pose on the stage of Kosciuszko Auditorium. Pictured from left to right are the following: (front row) Charlotte Korczynski and Carole Collins; (back row) Carole Chiras, queen Eleanore Nachorski, and Bernadette Majewski. "Rhapsody in Stardust" was the theme that the junior class chose to honor the seniors.

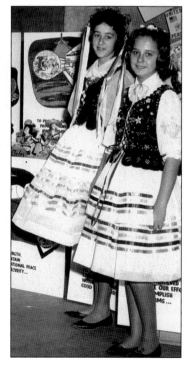

Janice Baniukiewicz (left) and Ann Marie Gebski, dressed in homemade Krakowianki outfits, represent Poland at United Nations Day in Worcester Memorial Auditorium in October 1960. This event celebrated diversity and was popular among area students.

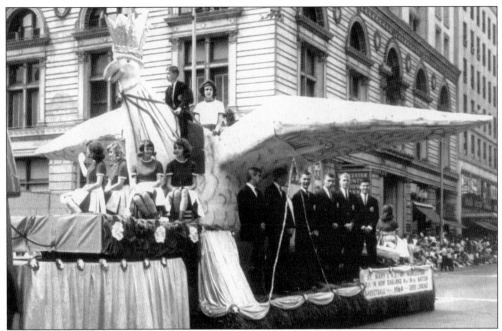

The St. Mary's High Eagle float soars down Main Street as part of the Catholic Youth Conference annual parade in 1964. The float paid tribute to the basketball and cheerleading teams' championship efforts. That year, the hoopsters ranked first in New England and fourth in the nation.

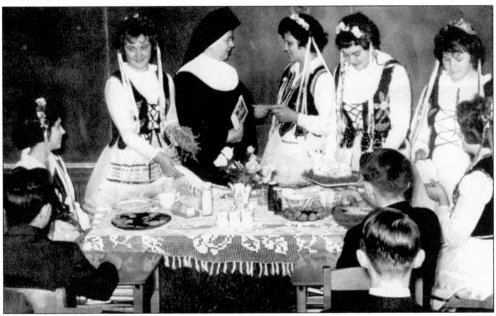

A table set for a traditional Christmas Eve *wigilia* meal stimulates discussion in a freshman world history class in 1961. Standing from left to right are Gayle Plotczyk, Sister M. Balthasare, Jane Michalak, Patricia Benoit, and Diane Siergiej. At *wigilia*, families shared an *oplatek*, or unconsecrated wafer, good wishes, and a meatless meal of an odd number of dishes. Midnight Mass followed.

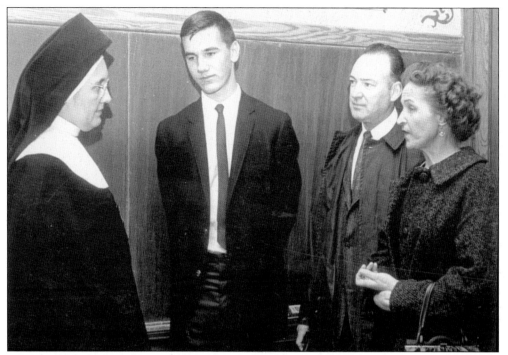

Sr. Mary Roberta discusses the academic accomplishments of Robert Szklarz (second from the left) with his uncle and aunt, Irving and Adeline Conner, during a parent-teacher's day at St. Mary's High in 1963. Sister Roberta taught chemistry and physics.

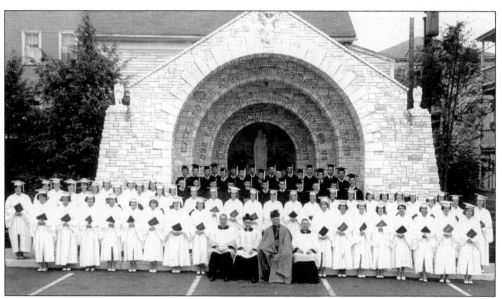

The 76 graduates of the St. Mary's High Class of 1964 pose at the parish shrine for their final group photograph. Most of them had been in school together since kindergarten. Commuting students from Clinton, Webster, the Warrens, and other Worcester County towns also attended St. Mary's High. Seated from left to right are Revs. Chester Janczukowicz and Anthony Nasiatka, Msgr. Charles Chwalek, and Rev. John Szamocki.

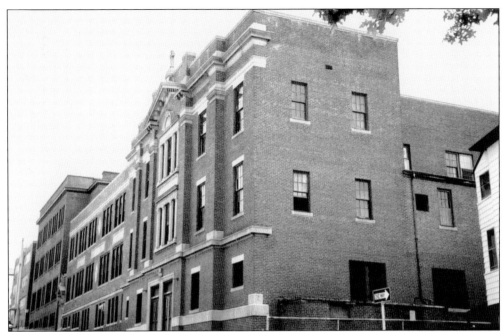

St. Mary's dominates Richland Street between Ward and Vernon Streets. Closest to the bottom of the steep block is the 1928 addition that includes Kosciuszko Auditorium and the gymnasium. Next is the two-story section that was completed in 1920 and used as the high school throughout the 1950s and early 1960s. The original three-story elementary school, which opened in 1915, is to the east. The new high school, which opened in 1965, lies at the highest end of the school property.

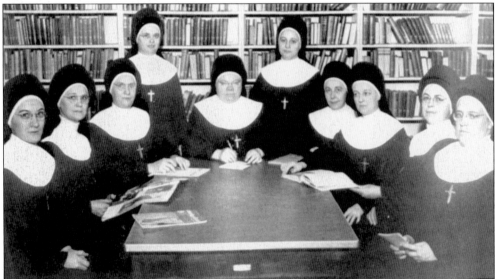

Sisters of the Holy Family of Nazareth serving as the St. Mary's High faculty in 1960–1961, from left to right, are Srs. Mary Sylvine, Benedict, Felixilla, and Matilda, Mother Superior Sr. Mary Assumpta, and Srs. Mary Thelma, Berchmans, Scholastica, Balthasare, and Gloria. The staff also included Revs. Charles Chwalek, Chester Janczukowicz, Anthony Nasiatka, and John Szamocki, who taught religion.

Seven

FALCONS, EAGLES, AND OTHER CHAMPS

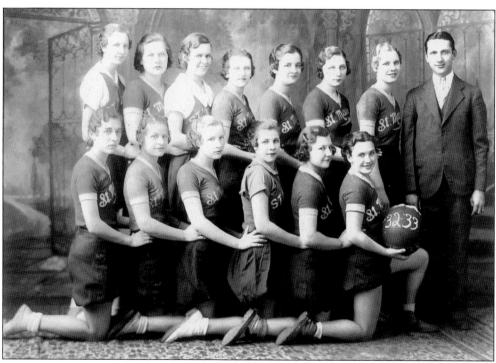

Shown is St. Mary's girls' basketball team of 1932–1933. From left to right are the following: (front row) Stasia Kwiatkowska, Helen Galkowska, Helen Szuba, unidentified, Jane Kasabula, and Grace Goicz; (back row) Helen Parzyk, Jane Waskiewicz, ? Kackiela, Jane Sendrowski, Louise Szuba, Stasia Marcinkiewicz, Sophie Modzelewska, and coach Joseph Serafin.

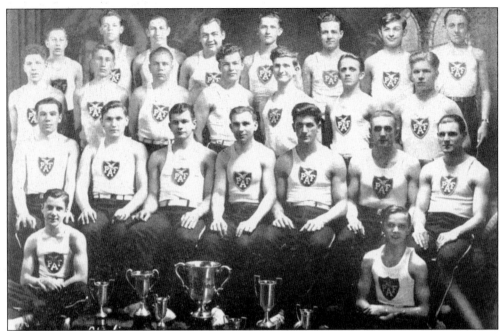

The Falcons' 1935 men's gymnastics team poses with seven trophies. From left to right are the following: (first row) J. Radula and C. Stoklosa; (second row) A. Lewinski, L. Sadowski, M. Wolk, District VIII and nest manager Joseph Gedymin, and nest managers C. Baldyga, S. Pawlina, and A. Kaminski; (third row) T. Stoklosa, L. Sadowski, W. Rogacz, W. Pieniadzek, S. Sadowski, C. Arczykiewicz, and H. Wolosz; (fourth row) J. Skibicki, K. Arczykiewicz, F. Kaminski, B. Witkowski, J. Dymek, Z. Lestownik, A. Stachelek, and H. Gebski.

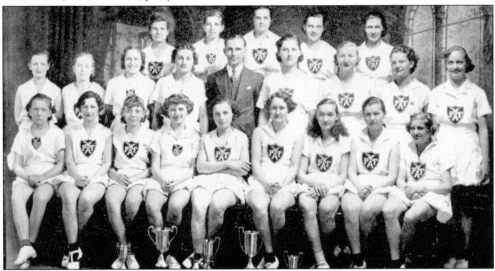

Five trophies grace this photograph of the Falcons' 1935 women's team. From left to right are the following: (front row) M. Gorczyca, S. Prostak, R. Potkaj, B. Zabinska, Nest 250 assistant manager G. Strakosz, O. Chryniak, A. Stefanska, V. Prostak, and H. Radzyk; (middle row) M. Prostak, H. Wolosz, H. Gedymin, N. Pawlina, nest manager Joseph Gedymin, M. Ciesluk, nest vice president J. Stochmal, L. Dymek, and S. Witkowska; (back row) J. Kiewra, R. Ostaszewska, H. Baniukiewicz, C. Strakosz, and Z. Gedymin.

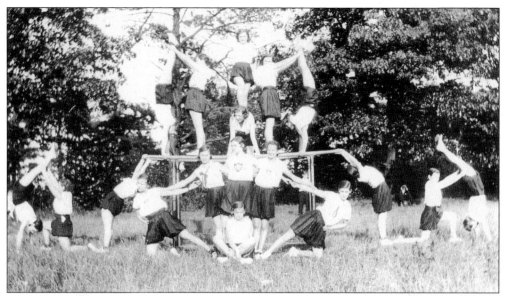

The Polish Falcons Nest 250 women's gymnastics team forms a pyramid with parallel bars. Nest 250, the local chapter, had a particularly strong program in the 1920s and 1930s, with instructor Joseph Gedymin shaping the award-winning Worcester team into one of the best in the United States. Developing physically and morally sound citizens had been one of the Falcons' goals since the organization's founding in Lwów, Poland, in 1867. *W zdrowym ciele zdrowy duch*—"in a healthy body dwells a healthy spirit."

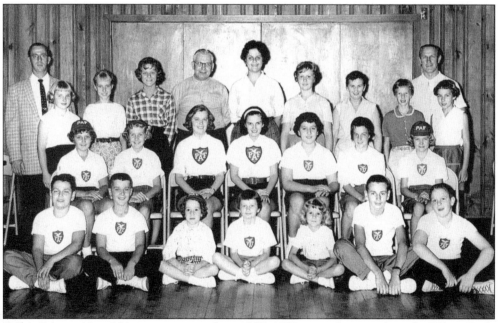

Polish Falcons Nest 250 gymnasts pose for a 1957–1958 team photograph at the White Eagle Club. Identified in the back row beginning with the third person on the left are Diane Gedymin, Judy Gutkowski, instructor Joseph S. Gedymin, Joyce Zabinski, two unidentified, persons, and Susan Niedzialkowska. Gedymin began supervising the Worcester chapter's program in 1936; he also served as the Falcons' New England athletic director for 30 years.

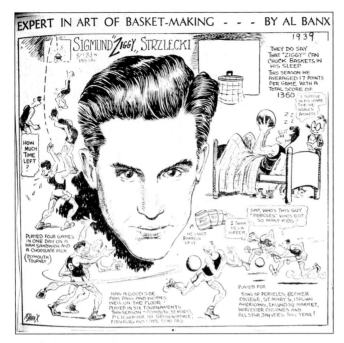

"The Art of Basket-making" takes on a whole new meaning in this Al Banx newspaper tribute to Sigmond "Ziggy" Strzelecki, Worcester's leading basketball player of the 1930s and 1940s. From November 1938 to April 1939, the 19-year-old Strzelecki played forward and guard for seven different teams, totaling 80 games. The season included six tournaments and a trip to New York City during Christmastime. (Reprinted with permission of the *Worcester Telegram & Gazette*.)

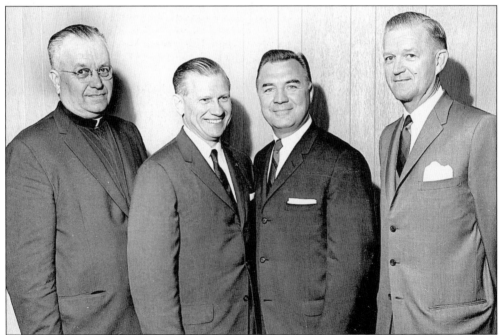

Pictured from left to right, the Reverend Charles Chwalek, Gov. John A. Volpe, Eddie Urbec, and master of ceremonies Joseph Benedict pose for the camera during a 1962 testimonial honoring Urbec's achievements in boxing. Then a member of the Massachusetts Boxing Commission, Urbec started out as a schoolboy boxer at the Ionic Avenue Boys' Club, became a standout as an amateur and pro officiator, and worked national and international contests including the Olympics and Pan American tournaments. (Reprinted with permission of the *Worcester Telegram & Gazette*.)

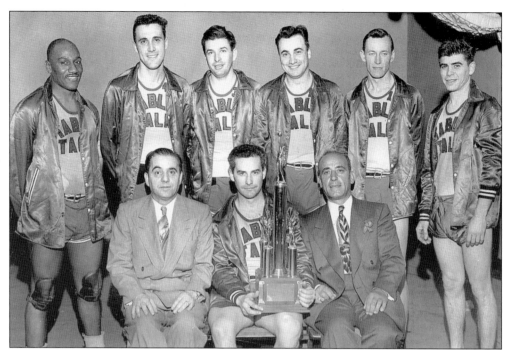

Table Talk player-manager-coach Ziggy Strzelecki holds the championship trophy of the Eastern Pro tournament that was played March 10–12, 1949, at Mechanics Hall. The tournament attracted the region's outstanding pro-basketball teams. The Harlem Yankees, Jersey City Reds, Buffalo Bisons, Pittsburgh Raiders, and the House of David competed before crowds ranging in size from 950 to 1,300 spectators.

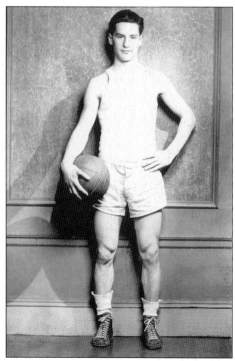

Sigmond Richard Strzelecki was named to the *Evening Gazette*'s Inter-High All-Star Quintet in 1937 for his accomplishments at Commerce High School. He set school records during his two years at Becker College and was the country's second leading scorer in his last three seasons at Clark University. He was considered a phenomenon. "He throws 'em up there all night and he rarely comes off the floor with less than 20 points," a 1939 newspaper article observed. In December 1999, the *Worcester Telegram & Gazette* named Strzelecki the Central Massachusetts Athlete of the Century.

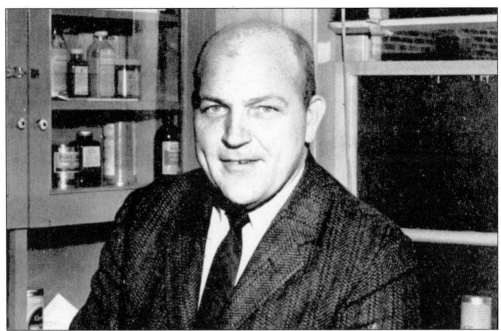

William Samko takes a break from his duties as St. Mary's High School's athletic director and head of physical education *c.* 1959. During his 40-plus-years of service at the school, Samko also enjoyed a private sports medicine practice, catering to the high schools of the city of Worcester and the College of the Holy Cross and Assumption College. In 1968, he was inducted into the Sports Medicine Hall of Fame in Dallas, Texas.

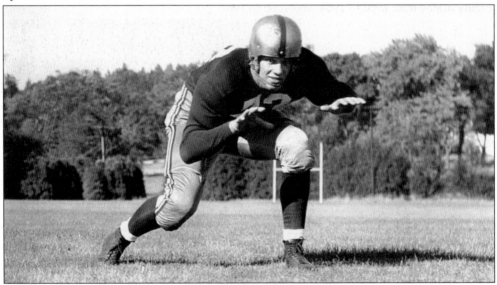

Lucien Prokopowich played football for four years at the University of Massachusetts. In November 1952, the *Springfield Union* wrote, "Pro has established a reputation throughout New England as a defensive terror at his tackle post. A human roadblock to the enemy backfield, Prokopowich, an outstanding military and academic student, will be hard to replace next season." A 1953 graduate, Prokopowich was a dean's list student who lettered in varsity football and swimming.

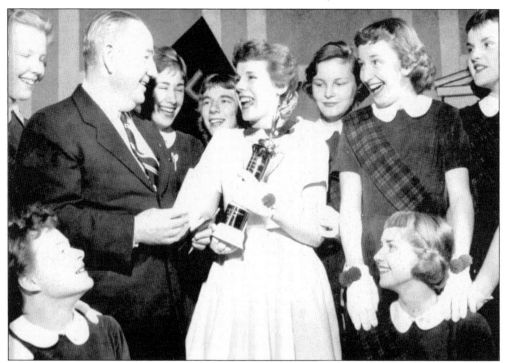

Worcester Telegram & Gazette cartoonist Al Banx presents the first-place trophy for the 1957 David Prouty Cheerleading Tournament to captain Barbara Lemanski and the rest of the St. Mary's High team. St. Mary's cheerleaders went on to winning streaks that claimed the top Prouty trophy from 1960 to 1964, and 1966 to 1969.

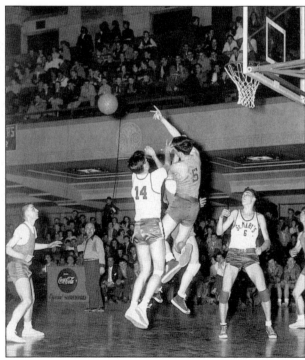

St. Mary's competes against St. Louis High School of Webster for the 1952 district championship in a game at Worcester Auditorium. St. Louis was victorious, led by their star player, ? Lonergan (5). Identified Eagle players are Peter Naumnik (14) and Bob Zdonczyk (6). In the background, referee Ziggy Strzelecki can be seen in front of the scorer's table.

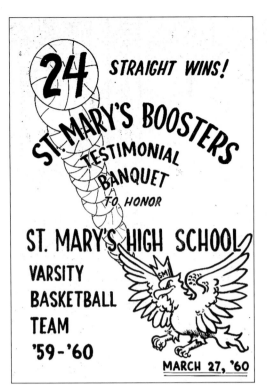

A program from the March 1960 St. Mary's Boosters banquet honoring the high school's 1959–1960 varsity basketball team conveys excitement about "24 straight wins." The Eagles ended their regular season with an 18-0 slate and then defended their Catholic League B title and the New England Class B championship, also claiming the Class A championship at the Assumption College Invitational Tournament.

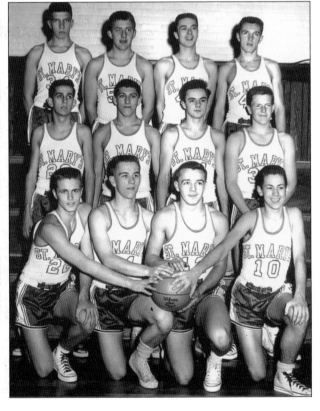

Pictured here is the undefeated 1959–1960 St. Mary's High basketball team. From left to right are the following: (front row) Richard Kuchnicki, Robert Demarski, Ronald Molis, and Richard Karwiel; (middle row) Robert Baniukiewicz, Richard Kaminski, Robert Kubicki, and Robert Kopacz; (back row) Richard Milaszewski, Richard Waskiewicz, Edward Gorak, and Joseph Kosciuszko. Kosciuszko, Waskiewicz, Gorak, and Molis all served as co-captains.

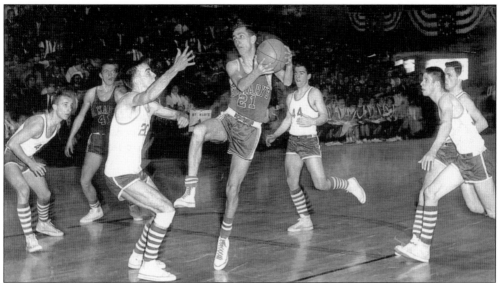

Bob Baniukiewicz (21) goes in for a lay-up, playing against Immaculate Conception High School of Newburyport in the semifinal game of the 1959–1960 New England Catholic Tournament. Joe Kosciuszko (41) positions himself for a rebound. The team successfully captured the trophy as the New England Class B Champions. Baniukiewicz was the only player in the school's history to have played in a 30-game winning streak, which included the last three games in the 1958–1959 season, the 24 straight wins 1959–1960, and the first three games in 1960–1961, the year he served as captain.

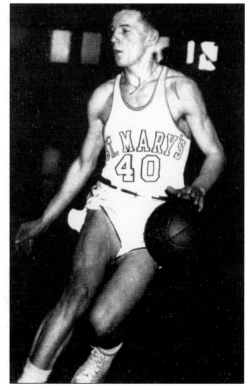

One of the most remarkable players in St. Mary's High history, Joe Kosciuszko is shown here in the 1958–1959 season. Then a junior, Kosciuszko won a Most Valuable Player (MVP) award in the New England Catholic High School Invitational Tournament. It was the first time in the tourney's 26-year history that a Class B school player was honored as MVP. Kosciuszko racked up 88 points in the three-game series.

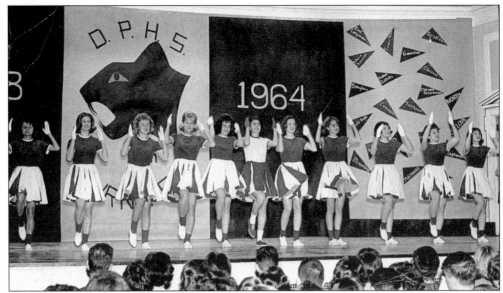

St. Mary's squad takes the stage at the 1964 David Prouty High School Cheerleading Tournament. Pictured performing another championship routine are, from left to right, Lorraine Szczurko, Carol Kach, Gayle Plotczyk, Judy Gutkowski, Janice Baniukiewicz, captain Helen Eddy, Ann Stuczynski, Elaine Kubicki, Diane Mendys, Ursula Bauer, and Janice Wondolowski.

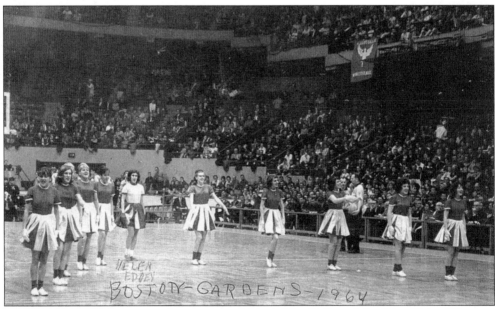

The St. Mary's High varsity cheerleaders, dubbed "the Belles of St. Mary's" by *Worcester Telegram & Gazette* cartoonist Al Banx, show their pride at Boston Garden where they cheer their basketball team on to capture the 1964 New England Championship. For four years, three senior Belles, Janice Baniukiewicz, Helen Eddy, and Diane Mendys, cheered the hoop stars on to many victories.

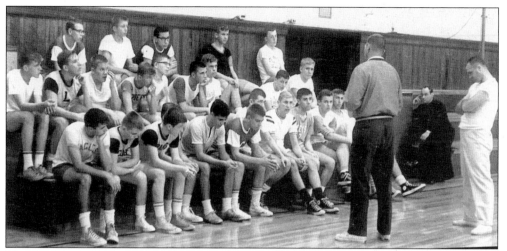

The St. Mary's High 1963–1964 varsity basketball team tryouts begin as coach Bill Ferris (standing on the left) and assistant coach Bob Ackerson (right) ponder which of the nearly 30 seated candidates will make the cut. The 12 chosen ultimately led the Eagles to victory at the New England Interscholastic Basketball Tournament and a rank of fourth-best high school team in the nation.

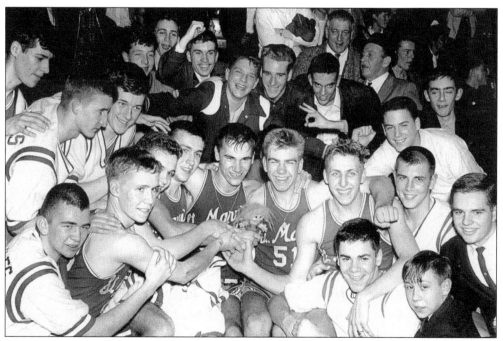

Fans crowd around the overjoyed St. Mary's High Eagles after their Western Massachusetts championship win. Team personnel pictured, from left to right, are as follows: (front row) Tom Kasprzak, team manager George Zinkus, and scorekeeper John Kraska; (middle row) Dick Rojcewicz, Bob Listewnik, Ron Gutkowski, co-captains Al Stazinski and Bob Szklarz, Paul Sztukowski, Ron Baronoski, and Wally Wondolowski; (back row) Gene Zabinski, Gerry Nowosacki, and Norm Daigle.

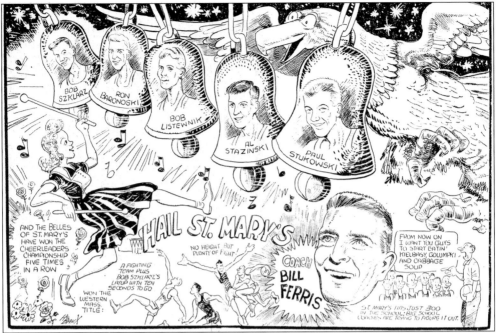

Evening Gazette cartoonist Al Banx paid tribute to the St. Mary's High Eagles' New England championship win with a special accolade on March 23, 1964. In the same issue, sportswriter Chick Morse marveled, "How about that? Little St. Mary's, a school of 288, including 133 boys, situated in the heart of the 'Island District' being the first Worcester school and also the only parochial school to annex this title in the 39 years of its history. It is an incredulous story." (Reprinted with permission of the *Worcester Telegram & Gazette*.)

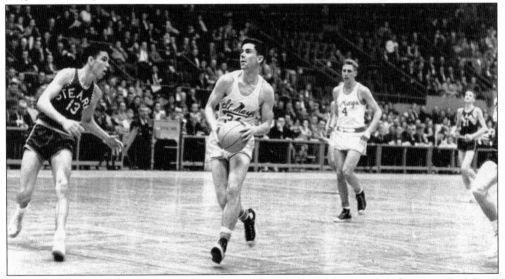

Stearns High School's All–New England guard Jon McDonald is an unlucky 13 as St. Mary's High's Tom (Zack) Kasprzak drives on for a basket—or maybe to pass to the "trailer," his best friend Ron Baronoski—in the Eagles' fast break offense during the March 19, 1964, quarterfinals of the New England tournament at Boston Garden. Representing Western Massachusetts, St. Mary's defeated the Millinocket (Maine) team 71-52.

Tom Kasprzak drives to the hoop for a basket against an East Providence Townie during the semifinal game on March 20 at Boston Garden. The blistering Eagle pace is exemplified by no fewer than five St. Mary's High players around the hoop and only two Townies defending. Eagles pictured from left to right are Paul Sztukowski (12), Kasprzak (34), co-captain Al Stazinski (42), Dick Rojcewicz (50), and Ron Baronoski (4). Illness prevented Bob Szklarz from playing. With 26 points from Stazinski, the Eagles flew to a 72-57 victory.

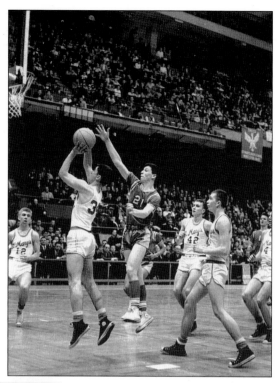

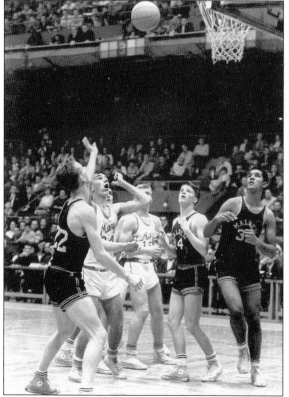

St. Mary's High co-captain Bob Szklarz (24) follows through on a short jump shot with plenty of Malden High School opposition hoping for a rebound that will not come in the March 21st finals of the New England tourney. To his left are Paul Sztukowski (12) and co-captain Al Stazinski (42) just behind. The shorter but quicker Eagles combined relentless defensive pressure with ferocious rebounding in the quest for the championship. Szklarz's eight consecutive free throws against Malden in the final two minutes of the March 21 game sealed the New England championship for the Eagles, 77-65.

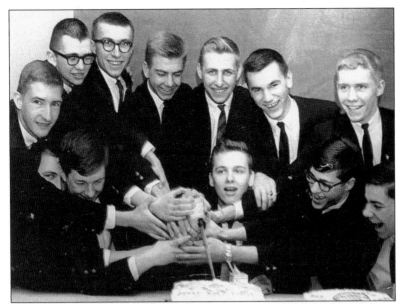

After their triumphant series at Boston Garden, the Eagles get ready for a treat decorated with a popular cheer: *Jeszcze raz!*—"Once again!"

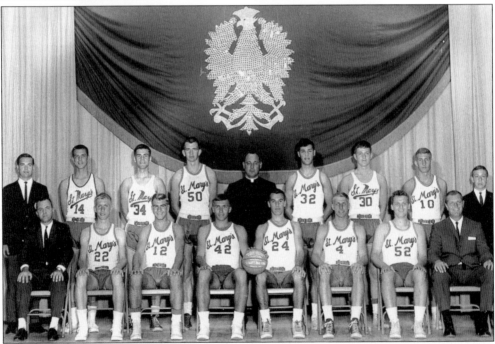

A banner bearing the Polish eagle serves as a fitting backdrop for this 1964 photograph marking the end of a spectacular St. Mary's High basketball season. From left to right are the following: (front row) assistant coach Bob Ackerson, Bob Listewnik, Paul Sztukowski, co-captains Al Stazinski and Bob Szklarz displaying the 1964 New England Championship basketball, Ron Baronoski, Ron Gutkowski, and coach Bill Ferris; (back row) scorekeeper John Kraska, Wally Wondolowski, Tom Kasprzak, Dick Rojcewicz, athletic director Father Chet Janczukowicz, Gene Zabinski, Norm Daigle, Gerry Nowosacki, and manager George Zinkus. The community was impressed with the players' characters as well as their skills; sports columnist Gus Cervini praised their "one for all and all for one" spirit.

Eight

EMBRACING CITIZENSHIP

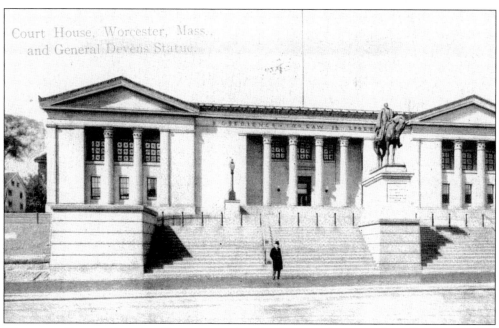

Worcester County Superior Court, operating in the courthouse at Lincoln Square, had jurisdiction over naturalization requests filed by the city's large immigrant population. Becoming a U.S. citizen generally followed a five-year, two-step process. After two years of U.S. residence, an alien could file the first papers, or declaration of intent. Three years later, the petition for naturalization could be submitted for review. Approval resulted in a certificate of naturalization.

Form III_____ Petitioner's Form Number_____

REPORT ON EDUCATIONAL STATUS OF APPLICANT FROM
_____SCHOOL DEPARTMENT TO NATURALIZATION OFFICE

1. Name *Anna Prokopovich*

2. School Attendance *1 term 1½ hr a week*
 yrs. hrs.

3. Knowledge of government and history *Good*

4. Understanding-attitude-behavior *Good*

5. English ability
 a. Speaking *Good* ; b. Reading *Good* ; c. Writing *Fair* ;

6. Recommendation *V. Good*

7. Signature of supervisor *Catharine A. McHugh*

8. Signature of teacher *Margaret L. McCarthy*

This report card issued by the Worcester School Department assessed an immigrant's mastery of skills needed to become a U.S. citizen. Anna Prokopowich earned a "very good" recommendation for naturalization after her first semester of study. Coursework focused on history, government, and English.

The Commonwealth of Massachusetts

DEPARTMENT OF EDUCATION

DIVISION OF

UNIVERSITY EXTENSION

This is evidence that *Anna Prokopovich*

has attended regularly an *Adv. For. Born Course* in

English for American Citizenship

conducted at *Ward St. School* under authority of Secs. 9 and 10, Chap. 69, General Laws. Attendance *122* hours, from *Oct. 5, '42* to *Mar. 25, '43*.

Date *March 25, 1943.*

_____ *Walter F. Young*
State Supervisor of Adult Alien Education Superintendent of Schools

 Thomas J. Power
 In Charge of Adult Alien Education

The six-month-long Advanced Foreign Born Course in English for American Citizenship entailed more than 120 hours of night school attendance. Immigrants living on the Island were enrolled at the Lamartine, Millbury, and Ward Street elementary schools. An Adult Alien Education office within the Massachusetts Department of Education oversaw the program.

In 1940, the Worcester School Department held its 20th annual Assembly of Nations, a program that awarded immigrants diplomas and certificates for completing Americanization and night school courses. The *Worcester Daily Telegram* reported that the April 24th ceremony honored more than 1,100 people, "many of them middle-aged," representing 27 nationalities.

TWENTIETH
ANNUAL ASSEMBLY OF
NATIONS

UNDER AUSPICES OF
PUBLIC SCHOOL DEPARTMENT
WORCESTER, MASS.

WEDNESDAY EVE., APRIL 24, 1940
AT 8 O'CLOCK
HIGH SCHOOL OF COMMERCE HALL

Presiding Officer
THOMAS F. POWER
Assistant Superintendent of Schools

Program Arrangement
CATHARINE A. McHUGH
Director of Americanization

MUSIC BY
EVENING HIGH SCHOOL ORCHESTRA and GLEE CLUB
Under Direction of
MICHAEL ABRUZZESE

Souvenir Flags presented by Gen. Charles Devens Circle No. 30
Ladies of the G. A. R.
American Creed presented by Col. Timothy Bigelow Chapter
D. A. R.
Perfect Attendance Award presented by Massachusetts
D. A. R.

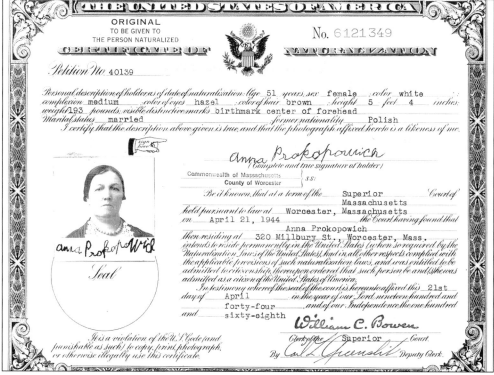

A certificate of naturalization documented the attainment of U.S. citizenship. Census research indicates that about 75 percent of America's eligible immigrants had become citizens by 1930. Anna Prokopowich came to America in 1913 but did not become a citizen until 1944. A mother of nine, she postponed the process due to family and work responsibilities.

Attorney Harry Meleski graduated from Boston University School of Law in 1922 and was appointed as an assistant U.S. attorney for Massachusetts in 1931. Meleski served as Worcester assistant city solicitor from 1945 to 1953, and city solicitor from 1953 to 1968. He was president of the Polish Naturalization Independent Club from 1925 to 1927 and active for many years in local Polish American organizations.

Msgr. Boleslaw Bojanowski (left) and U.S. Rep. John F. Kennedy watch as state Rep. Stanislaus G. Wondolowski (Ward 5) presents Alice Belina with the charter for the auxiliary of the Polish-American World War II Veterans of Massachusetts. Kennedy was the principal speaker for the statewide Polish-American Veterans convention held in Worcester June 2–3, 1951. Some 600 delegates attended the closing session at St. Mary's Kosciuszko Auditorium.

Some community leaders enjoy dinner during an October 5, 1947, testimonial honoring Sgt. Boleslaw P. Izbicki. Seated from left to right at the head table are Izbicki, Joseph T. Benedict, unidentified, and Rev. Ladislaus Radzik. Izbicki, then serving in the Worcester Police Department's Radio Division, retired years later as a deputy police chief.

Anthony E. "Archie" Golembiewski was the first Polish American and Polish Naturalization Independent member elected to municipal office in Worcester. He won a school committee seat in 1934, representing Ward 5—the home of 90 percent of the city's Poles. Golembiewski cofounded and operated Archie's Men's Shop, which for decades was one of Millbury Street's most successful retail stores. He was also active in athletics.

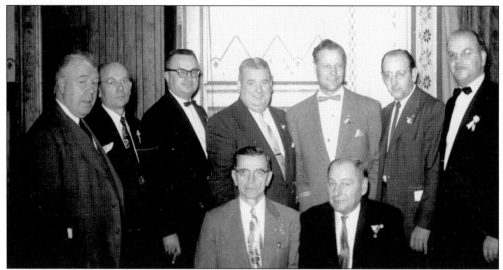

An unidentified event, probably in the 1950s, brings politicians and community leaders to Kosciuszko Auditorium. Standing from left to right are Harold D. Donahue, who represented Worcester in the U.S. House of Representatives; John Bylinski; Eugene Galkowski; James D. O'Brien, an Island native who served as mayor of Worcester (1954–1958 and 1960–1961); Frank Swierzbin; John Burzynski; and Stanislaus G. Wondolowski, a Worcester representative in the Massachusetts Legislature. The seated men are unidentified.

Stephen J. Rojcewicz (left) presents Joseph T. Benedict with the 1959 St. Mary's Boosters Diamond Pin Award, honoring his contribution to youth programs at Our Lady of Czestochowa Parish. Benedict was the third recipient of the annual Boosters Award. A banker and civic leader, Benedict displayed leadership in numerous Worcester area organizations. (Reprinted with permission of the *Worcester Telegram & Gazette*.)

Nine

IN THE MILITARY

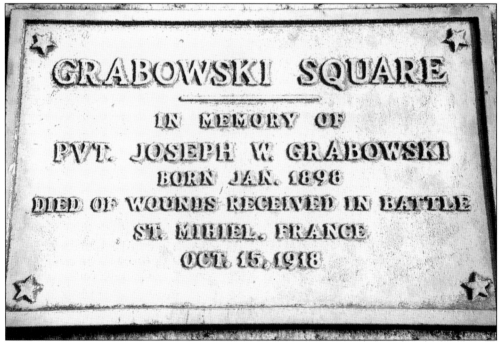

A plaque on a granite monument commemorates one of the Polish community's young men who lost his life serving in the U.S. Army in World War I. Pvt. Joseph Grabowski was 20 years old when he died of wounds suffered in battle at St. Mihiel, France. The intersection of Lafayette, Harding, and Washington Streets was named Grabowski Square in his honor. Two monuments on a small green mark the site.

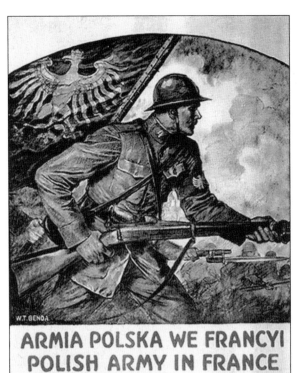

As an alternative to serving in the U.S. military during World War I, immigrant Poles and U.S.–born Polish Americans could choose to serve in the Polish Army fighting in France under Gen. Józef Haller. Worcester's Polish Falcons Nest 250 operated Recruiting Center No. 32, where approximately 200 men signed up to join Haller. They included Stanislaw Goszczowski, Edward Grodzki, and Dominik Usewicz.

ARMIA POLSKA WE FRANCYI
POLISH ARMY IN FRANCE
CENTRUM REKRUTACYJNE N.º
RECRUITING CENTRE

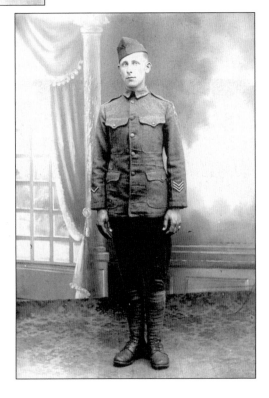

Maximillian Joseph Fortune served in the U.S. Army in World War I. Born in a log cabin in Heidelberg, Minnesota, in 1898, Fortune grew up on Lafayette Street and attended Lamartine Street School. He was the son of Józef and Mariana Grochowalski Fortuna, who arrived in the United States in 1890 and after spending a few years in the Midwest, settled in Worcester in 1903.

A unit of Polish Army veterans disbands in front of the White Eagle building on Green Street following a parade in 1937. An awning over the doorway identifies Arcadia Hall, and signs above announce dancing and an upcoming military ball.

A rare 1937 photograph captures approximately two dozen Polish Army veterans as they march north on Millbury Street, their formation neatly outlined by trolley tracks. They are approaching Richland Street on a route that probably passed through Kelley Square to conclude on Green Street at the White Eagle hall. Apartments above the storefronts on Millbury Street provided housing for hundreds of families.

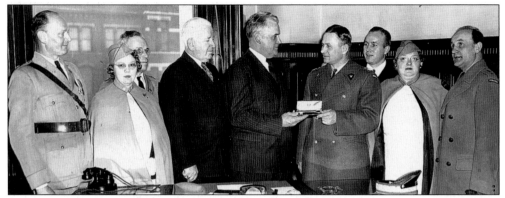

Gen. Bronislaw Duch, commander of the Free Polish Forces in Canada and an officer in Anders' army, accepts a key to the city of Worcester from Mayor William Bennett during a visit in February 1942. Members of the Polish Army Veterans and Auxiliary look on. From left to right are Walter Krukowski, Helen Waluk, Anthony Dowgiert, U.S. Rep. Harold Donahue, Bennett, Duch, Harry Meleski, Helen Piaszczyk, and Capt. George Ciepielowski, an aide.

UNITED STATES TREASURY DEPARTMENT

For distinguished services rendered in behalf of the War Savings Program this citation is awarded to

Americans of Polish descent in Worcester, Massachusetts

Given under my hand and seal on October 25 1943

Henry Morgenthau Jr.
SECRETARY OF THE TREASURY

A certificate from the U.S. Treasury Department honors the contributions of Worcester's Polish community to the War Savings Program in 1943. Profoundly affected by Poland's plight during World War II, these Americans of Polish descent were active in raising money and gathering needed supplies through various drives. The parish was also involved with the efforts of the War Relief Services of the National Catholic Welfare Conference.

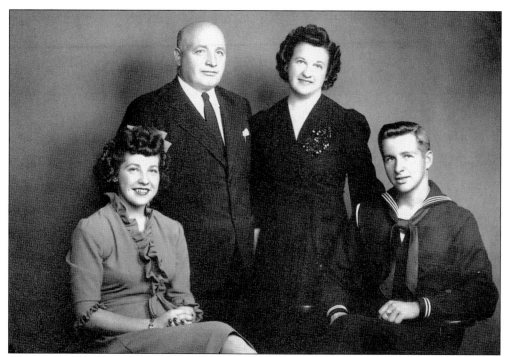

The Karpuk family of 113 Ingleside Avenue poses for a formal portrait during World War II. Seated are daughter, Jeannette, and son, John, who enlisted in the U.S. Navy as a teenager. Standing are parents Michael and Katherine. Michael Karpuk was a baker at B.F. Arnold Company and his wife, a waitress at Charles Restaurant.

While on furlough from their tours of duty in October 1943, Army Pvt. Joseph Wondolowski (left) and his brother, Cpl. Stanley Wondolowski, shake hands next to their parents' home at 177 Vernon Street. Joseph served as a dental assistant in England, while Stanley served as a baker in Iceland.

Roger Zabinski, serving in the U.S. Navy's Seabees, pauses in the entrance of a cave on Iwo Jima in 1945. Three Seabee battalions landed there with the Marines on D-day, February 19, 1945. Others followed, working on cleanup and airfield construction. The hard-fought battle to secure Iwo Jima made possible the development of an air base that was strategically vital to ultimate American victory in the Pacific.

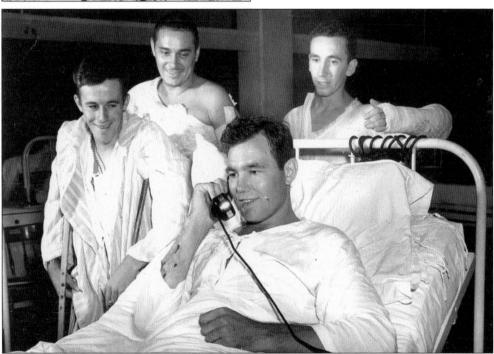

Al Prokopovich, standing in the center, smiles as an unidentified fellow patient enjoys a phone call from his hospital bed in April 1945. Severe wounds sustained at Iwo Jima kept Prokopovich at the U.S. Naval Hospital in Philadelphia for a year. Prokopovich served on a navy gunboat that suffered extensive shelling from the Japanese in the February 17 pre-invasion maneuvers. He later shortened his name to Proko.

U.S. Air Force Staff Sgt. Henry Galkowski is pictured in Europe where he was stationed during World War II. Galkowski flew on 53 bombing missions over Italy. This photograph was taken in 1943. An inscription on the back reads "8th Air Force, England."

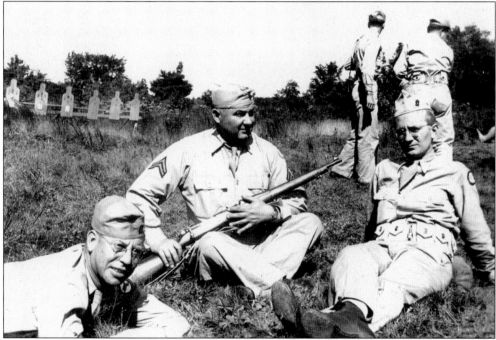

John D. Zaleski (right) takes a break on the rifle range in 1943. He served on active duty in the Massachusetts National Guard for some 12 years, until the mid-1950s, and then in the reserves. Achieving the rank of corporal in the 3rd Company, 21st Infantry, he was given an office assignment because of his associate degree in business administration. When a tornado devastated Assumption College in the summer of 1953, Zaleski's unit was among those called to action.

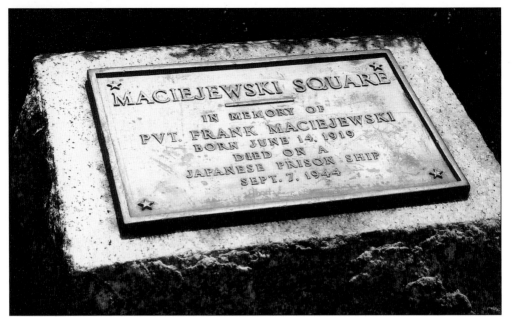

A monument at Perry Avenue and Seymour Street commemorates Pfc. Frank Maciejewski. The 22-year-old had already completed military service when he reenlisted in 1941. He was taken prisoner by the Japanese in the fall of Corregidor, in May 1942, and held as a prisoner of war at Mindanao for two years. He was among hundreds of Americans killed in September 1944, when a U.S. torpedo hit and sank the Japanese prison ship that was transporting them to a labor camp.

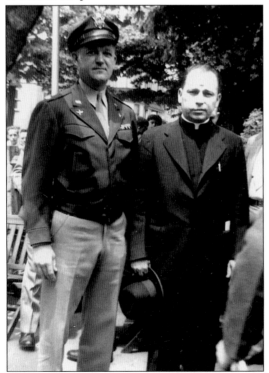

Joseph T. Benedict (left), past commander of the Polish-American Veterans of World War II, stands with the post's chaplain, Rev. Ladislaus J. Radzik, at the newly dedicated Maciejewski Square in May 1947. Benedict placed a wreath at the site, and Radzik offered the benediction during the ceremonies, which were attended by a sizeable crowd.

A 1947 sketch by John Bushong captures the likeness of U.S. Army Pfc. Frank Maciejewski. The portrait was presented to his family as part of the 1947 dedication ceremonies for Maciejewski Square. The private was the son of Stanley and Helen Maciejewski. He graduated from St. Mary's School in 1933 and Worcester Boys' Trade School in 1937.

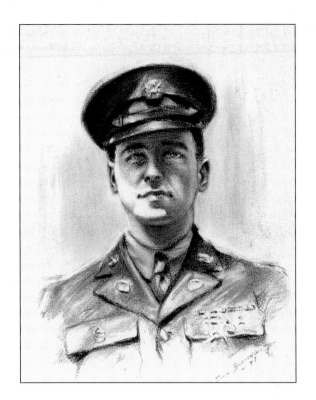

DEDICATION

OF

MACIEJEWSKI SQUARE

COR. PERRY AVE. AND SEYMOUR ST.

in honor of

PVT. 1ST CLASS FRANK J. MACIEJEWSKI

SUNDAY, MAY 25, 1947 AT 12:45 P. M.

by

Polish American Veterans of World War II
Worcester, Massachusetts

This program offers details of the May 25, 1947, ceremony for the dedication of Maciejewski Square. The effort was sponsored by Worcester's newly formed chapter of the Polish-American Veterans of World War II. The Polish National Alliance Drum and Bugle Corps, a firing squad of the Wheaton Post Veterans of Foreign Wars, several politicians, and St. Mary's parish priests were among the participants in the event.

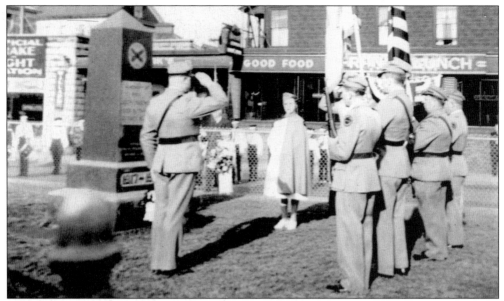

Members of the Polish Army Veterans and Auxiliary salute during Memorial Day ceremonies at Grabowski Square on May 30, 1946. Visible in the background is Frank's Lunch at Washington and Lafayette Streets. State Rep. Stanislaus Wondolowski made this photograph with a Brownie reflex camera.

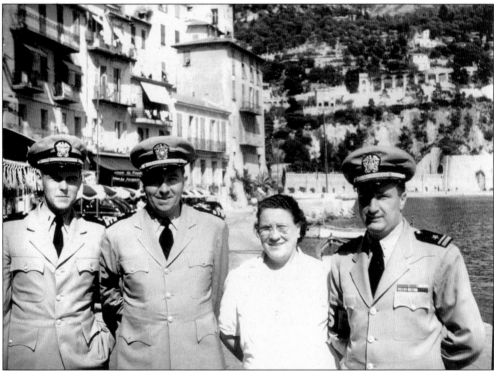

In this scenic 1952 photograph of Villefranche, France, Lt. Edward F. Swillo (far right) stands with Nautic Restaurant owner "Mama" Germaine and two of his shipmates from the heavy cruiser USS *Salem*.

Col. Joseph T. Benedict and Worcester Mayor Andrew Holmstrom place a wreath at the Lincoln Square memorial during Armistice Day ceremonies November 11, 1950. Visible in the background are three members of the Polish Army Veterans Auxiliary. (Reprinted with permission of the *Worcester Telegram & Gazette*.)

The Reverend Charles Chwalek, Gold Star mothers, and members of the Polish-American Veterans of World War II and Auxiliary listen solemnly as the Polish National Alliance Drum and Bugle Corps musician plays taps during a Memorial Day observance in the late 1950s. Some 50 servicemen from the parish died in the war; white crosses and flags commemorate their loss. The ceremony was one of the last held at the shrine on the Ward Street side of the church. The grounds were reconfigured during the 1959 interstate construction.

Members of the Polish Army Veterans Post 52 and Auxiliary pose for a group portrait c. 1962. The setting for this photograph is the stage of Arcadia Hall at the White Eagle hall on Green Street. The Polish Army Veterans were active in the years following World War I. Later, World War II veterans joined the group. Some members were Poles who emigrated to settle in Worcester in the postwar years.

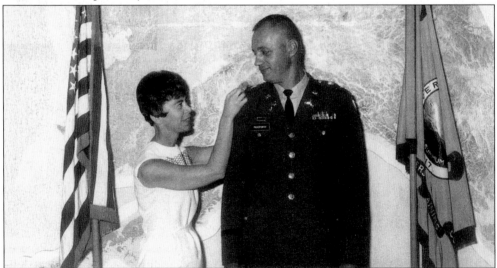

Lucien R. Prokopowich watches as his wife, Janet, affixes his new insignia to his epaulet, marking his promotion to lieutenant colonel in the U.S. Army in 1969. The ceremony took place in his office at the University of Alaska, where he had just been assigned as professor of military science. Raised on Millbury Street, Prokopowich served on several stateside bases and in Germany and Vietnam prior to his assignment in Fairbanks.

118

Ten

A Proud Heritage

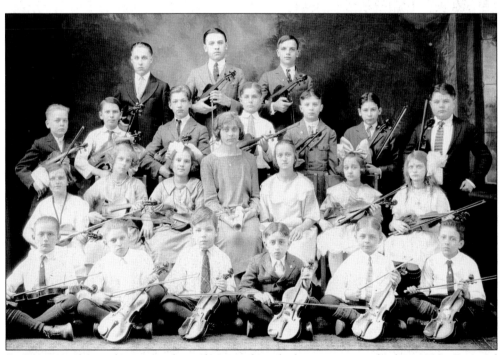

St. Mary's violin students pose for a photograph with their pianist in the late 1920s. Pictured from left to right are the following: (first row) William Kisiel, Frank Pruszynski, Joseph Budnik, Teddy Wolanin, Ed Barciak, and unidentified; (second row) Harriet Harko, unidentified, Natalie Wondolowska, pianist Agnes Golembiewska, ? Kwiatkowska, ? Kwiatkowska, and ? Rutkowska; (third row) Henry Kolakowski, ?, Zigmund Rutkowski, Ralph Sztukowski, unidentified, Leo Matyszczyk, and John Sheltinas; (fourth row) Stanley Pielaszczyk, Joseph Galkowski, and Stanislaus Wondolowski.

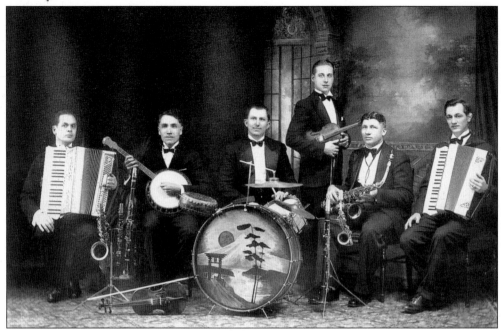

A varied display of instruments speaks to the versatility of the Joe Dackson Orchestra, pictured here c. 1928. The only member identified is John J. Stachura (far right). Born in Worcester in 1903, Stachura was an accomplished accordionist who played professionally and at social functions for 69 years.

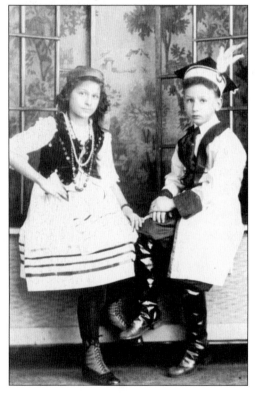

Helena Galkowska and Kazimierz Galkowski sit for a portrait dated January 30, 1926. They are wearing Krakowiak-style clothing—an embroidered vest, white blouse, and ribboned skirt with apron for her and a four-cornered hat, long white jacket, and boots for him. Poles adopted the Krakowiak style as their national ethnic dress; there are many different traditional styles within the country's various regions.

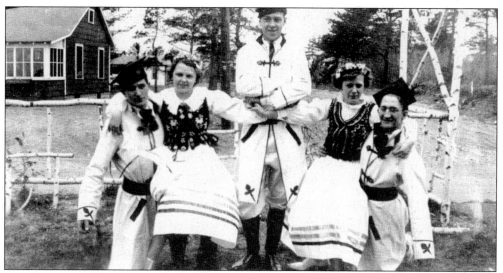

Krakowianki dancers strike a pose before a birch fence and archway reminiscent of the trees so common in Poland. Pictured from left to right are an unidentified dancer, Sophie Zabinski, Roger Zabinski, unidentified, and Walter Gedymin. The undated photograph may have been made in the late 1940s or early 1950s.

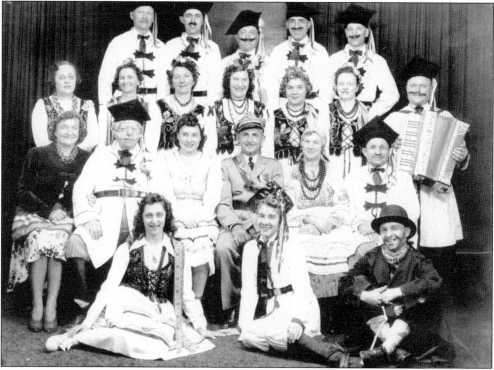

Cast members of *Krakowskie Wesele* pose in costume during the two-year run of this popular production *c.* 1942–1944. Stefania Gebski (third row, far left) wrote this and several other musicals. Performers were members of the Polish Falcons. The play opened at the White Eagle's Arcadia Hall and traveled to Southbridge and Webster. Profits of the productions during World War II went to the Polish Relief Fund.

Six couples pose for a photograph at the fifth annual military ball sponsored by the Polish-American Veterans of World War II. Pictured from left to right are the following: (front row) unidentified, Julia Zabinski, Dorothy Gut, Mary Gosk, Sophie Gosk, and Florence Bertaska; (back row) unidentified, Roger Zabinski, Walter Gut, Steve Gosk, Chester Gosk, and Joseph Bertaska. Johnny Menko and his orchestra provided music for the dance, held November 10, 1950, at the Arcadia ballroom.

Attending one of the early military balls sponsored by the Polish-American Veterans are, from left to right, Dr. T.J. Jankowski, Harriet Samborski, post chaplain Rev. Ladislaus Radzik, Agnes Jankowski, and attorney Charles Samborski. The Polish-American Veterans held a military ball each November on the weekend closest to the holiday now known as Veterans Day.

Mary and Joseph T. Benedict pose for a photograph at the first military ball organized by the newly formed Polish-American Veterans of World War II in 1946. Benedict served as the first commander of the Worcester post.

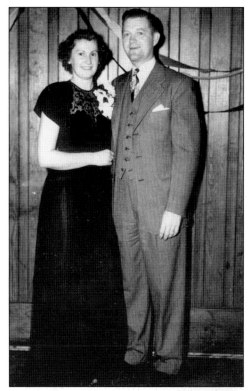

The officers of the White Eagle Club are gathered at their Green Street hall in this 1960 photograph. Pictured from left to right are the following: (front row) Mary Prostak, John Krukowski, John Wolanin, Felix Kwiatkowski, Stefan Krukowski, Walter Leyman, and Statia Kwiatkowski; (back row) Walter Broden, Kate Kwiatkowski, Walter Szczepaniak, John Bylinski, Tom Nadolny, Matthew Kwiatkowski, Chester Baniukiewicz, Chester Sieniawksi, Joseph Gedymin, Laura Wistaris, Joseph Kwiatkowski, and Vincent Kwiatkowski.

Leaders of Troop 71 acknowledge special achievements at a Boy Scout banquet *c.* 1961. Each of the 15 candles represents a different Scout value or ideal. Pictured from left to right are Robert Zukowski, Charles Wisniewski, Jack Zaleski, Mark Brown, Chester Leosz, ? Deveau, and Scoutmaster John Kasper.

Scoutmaster Frank Goicz displays the charter for the parish's new Boy Scout Troop 71, sponsored in the late 1940s by the Polish-American Veterans of World War II. From left to right are the following: (front row) two unidentified Mohegan Council Boy Scout representatives, Goicz, and Assistant Scoutmaster Steve Rojcewicz; (middle row) Henry Karolkiewicz, Rev. Casimir Swiacki, Charles Samborski, and Walter Rojcewicz; (back row) Ed Burak, Ted Jankowski, Edward Rojcewicz, Charles Wisniewski, Chester Stuczynski, and Frank Swierzbin. The presentation took place at Kosciuszko Auditorium.

The Polish Naturalization Independent Club at 290 Millbury Street was built in 1962, replacing a Foyle Street facility that was razed for the construction of the Worcester Expressway. The Polish Naturalization Independent Club was founded in 1906 to help new immigrants become naturalized citizens and support members' political ambitions. It funded tuitions for Polish immigrants to learn English. By 1956, the club had helped more than 3,000 of Worcester's Poles to attain citizenship. The club also provides facilities for functions such as wedding receptions and parties.

Standing in front of their zfour-man tent pitched at Treasure Valley are, from left to right, John Wojnarowicz, Alfred Stazinski, John Kraska, and Ronald Baronoski, all members of Boy Scout Troop 71 in 1959. At Treasure Valley, located in Paxton, Worcester County Boy Scouts could attend weeklong camping sessions to learn new Scouting skills, work on completing elements needed for merit badges, and simply have fun.

The Polish National Alliance on Lafayette Street serves as a social and cultural hub for the Polish community of Worcester. Worcester's Polish National Alliance Lodge 758 was established in 1906 as a chapter of the nationwide organization, now the largest ethnically based fraternal insurance benefit society in the United States. The Polish National Alliance worked to advance Poland's struggle for independence, as well as to immerse the immigrants in American society.

Musicians of the Cavaliers, a popular area dance band, set up to practice for a gig c. 1970. From left to right, Bolek "Billy" Lorenc, Walter Luciniak on drums, and Joseph Antas on accordion. The Cavaliers played at clubs, halls, and parties throughout central Massachusetts.

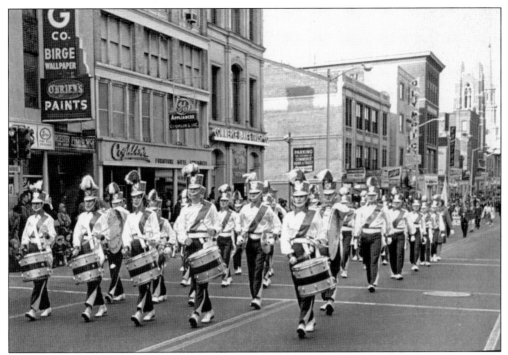

The award-winning Polish National Alliance Drum and Bugle Corps marches south on Main Street. Playing tenor drums in front are, from left to right, Elaine Barter, Ileen ?, Nancy ?, Fran Bujnowski, and Irene Nowak. A float from St. Mary's follows the drum corps in this early 1960s parade.

A side view of the Polish National Alliance's clubhouse at Dority Pond in Millbury shows a bit of beach in the foreground. The building, with a meeting room and bar on the first floor and a large ballroom on the second, was the site of many wedding receptions and dances. The Polish-American Veterans held their annual Polish picnics here in the summer, and members' families used the beach and pond for fishing.

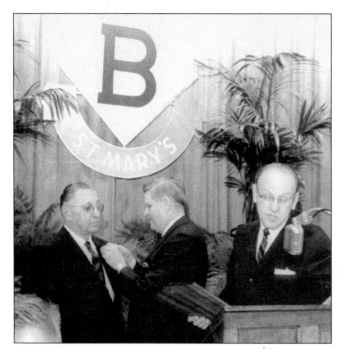

Andrew Gebski has the Diamond Pin award affixed to his lapel by Joseph Stodulski during the 1965 St. Mary's Boosters award banquet. Theodore Bierch stands at the podium, reading the inscription on the plaque presented to Gebski.

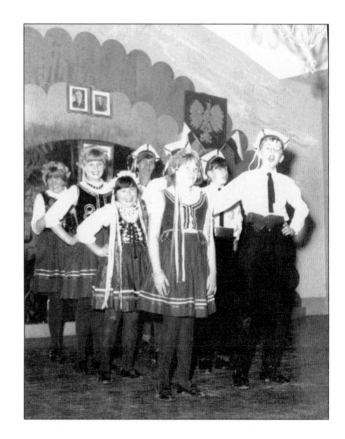

Frances Tarasiak and Michael Stepien lead a troupe of Krakowiak dancers in a performance at Arcadia Hall celebrating Poland's May 3 Constitution Day c. 1966. Their dance teacher was Sophie Gawronska.